D1409386

IMAGES
of America

ENFIELD
CONNECTICUT

10-25

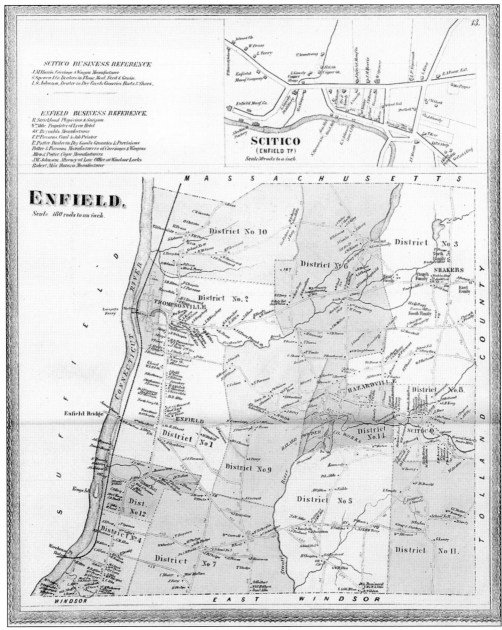

This map is from the *Atlas of Hartford City and County, Connecticut*. Published in 1869 by Baker & Tilden, it shows Enfield's districts at the time. The districts were as follows: (1) Enfield Street, (2) Thompsonville, (3) Shakers, (4) King Street, (5) Wallop, (6) Jabbock, (7) Weymouth, (8) Scitico, (9) London, (10) Brainard, (11) East Wallop, (12) Bement's Brook, (13) Thompsonville North, and (14) Hazardville. (EHS Collection.)

IMAGES
of America

ENFIELD
CONNECTICUT

Michael K. Miller

ARCADIA
PUBLISHING

Published by Arcadia Publishing
Charleston SC, Chicago IL, Portsmouth NH, San Francisco CA

Printed in the United States of America

Library of Congress Catalog Card Number: 98-89446

For all general information contact Arcadia Publishing at:
Telephone 843-853-2070
Fax 843-853-0044
E-mail sales@arcadiapublishing.com
For customer service and orders:
Toll-Free 1-888-313-2665

Visit us on the Internet at www.arcadiapublishing.com

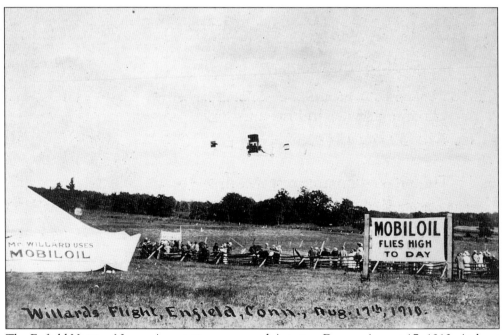

The Enfield Visiting Nurses Association sponsored Aviation Day on August 17, 1910. At least two postcards were published to commemorate the event and promote Mr. Willard's corporate sponsor. (MAP Collection.)

CONTENTS

ACKNOWLEDGMENTS

This book is the result of the efforts of several members of the Enfield Historical Society. Stanley Dynia, Reverend John Gwozdz, Wanda Lamana, Marjorie Nadeau, Richard O'Brien, Robert Sokol, Rose Sokol, Phyllis Tanguay, and Robert Tanguay contributed their time and knowledge to assemble, identify, and describe the images in this book. Also deserving recognition are the many individuals and organizations who donated the photos, postcards, and other images to the Society over the past four decades.

The images in this book are from several sources. Images identified with "EHS Collection" are from the Society's general collection housed at the Old Town Hall Museum. Images identified with "MAP Collection" are from the collection housed at the Martha A. Parsons House Museum. Images identified with "WS Collection" are from the collection displayed at the Wallop School Museum. Images identified with "Hilditch Photo Collection" are from the Harry Hilditch Collection, courtesy of Society member Doris Munsell, whose generosity is greatly appreciated. Finally, images contributed by other members of the Enfield Historical Society are identified with "Member Collection."

Errors and disagreement are inevitable in any historical composition, and this book is no exception. When carefully researched, "facts" taught for decades often turn out to be family traditions, educated opinions, or simple guesses. Much written history can only be traced to secondary sources. Even primary sources can be contradictory—when they can be found. While writing this book, the research team and I tried to discard unreliable information, to correct erroneous information that has previously been taken as fact, and to identify any traditions or stories as such. We welcome any information that our readers have that proves or contradicts any information in this book.

—Michael K. Miller

For more information about Enfield's history, please visit the Enfield Historical Society's museums:

The Old Town Hall Museum
1294 Enfield Street
Enfield, CT 06082

The Martha A. Parsons House Museum
1387 Enfield Street
Enfield, CT 06082

The Wallop School Museum
Wallop School Road
Enfield, CT 06082

INTRODUCTION

Enfield, Connecticut, is today a sprawling suburban community. Interspersed between modern homes, businesses, and shopping malls are many historic buildings. Most people pass by these buildings never knowing their stories, unaware of the town's rich and varied history. The images within these pages will illustrate some of those stories.

Two hundred million years ago, Enfield's earliest residents left evidence of their presence in sandy sediments that eons of pressure gradually turned to sandstone. Fossilized tracks of amphibians, reptiles, and dinosaurs occasionally weather out of the many cliffs along the Connecticut river. Twenty thousand years ago, the Wisconsinan Ice Sheet covered Enfield with thousands of feet of ice. Lake Hitchcock formed some 12,900 years ago when water from the melting glacier collected behind debris that had been pushed down the Connecticut Valley by the advancing glacier during its formation. It extended 150 miles along the Connecticut River valley from Rocky Hill, Connecticut, to Lyme, New Hampshire, covering much of what is now Enfield. Eventually, the debris dam failed, and the Connecticut Valley was drained.

Exactly when humans first inhabited Enfield is still a question. Native Americans may have lived along the shores of Lake Hitchcock. The first recorded contact between Europeans and Native Americans in Connecticut was in 1614, when Dutch explorer Adriaen Block sailed up the Connecticut River, possibly as far as Enfield. Less than a century later, Europeans had displaced the Native American population from what had become Enfield.

In 1674, the Town of Springfield, founded 26 years earlier, was granted additional land stretching from Asnuntuck Brook north to Longmeadow Brook by the General Court of Massachusetts. That same year, Springfield's John Pynchon built a sawmill on Asnuntuck Brook. It was the first European structure in what would soon become Enfield. The sawmill was burned one year later in 1675, when Metacomet, son of Massasoit and Chief of the Wampanoags, led an uprising known as King Philip's War in retaliation for the execution of three Wampanoags by the English.

Enfield's first settlers arrived in 1679 from Salem, Massachusetts. John Pease Jr. and Robert Pease dug a shelter into the side of a hill and camped for the winter. They brought their families the next spring. By the end of 1680, about 25 families had settled in the area. Just three years later, in 1683, the land extending east 10 miles from the Connecticut River and south 6 miles from Longmeadow Brook became the town of Enfield. On March 16, 1688, the townspeople purchased Enfield for 25 pounds Sterling from a Podunk Indian named Notatuck.

Over the next decades, settlement continued throughout Enfield. In 1713, settlers began clearing land in areas that would become the villages of Wallop and Scitico. By 1720, settlers had reached all parts of Enfield. The year 1734 saw history repeat itself when, just as Enfield had broken off from Springfield, Enfield's Eastern Precinct was incorporated as a separate town named Somers.

The boundary between Massachusetts and Connecticut was in dispute for many years. Massachusetts claimed the land that became Enfield, Suffield, and Somers, based upon a survey

made in 1642 by Woodward and Saffery. A 1695 survey put the towns within Connecticut's borders. The desire to separate from Massachusetts was first discussed in a 1704 Enfield town meeting, but the matter did not come to a head until 1747, when the affected towns applied to the legislatures of both colonies to be separated from Massachusetts and joined to Connecticut. The matter was also pursued in court in London, England. Finally, in 1750, Enfield seceded from Massachusetts, and Enfield's nearly 1,000 residents became part of Connecticut Colony.

In 1774, Enfield's historic third meetinghouse (a church) was built. Dedicated January 1, 1775, it is now a fitting home to the Enfield Historical Society.

Tradition has it that on Thursday, April 20, 1775, word reached Enfield that war had broken out in Boston. Reverend Elam Potter's regular Thursday sermon was interrupted by Private (later Captain) Thomas Abbey, who pounded on his drum outside the meetinghouse. The next day, 74 volunteers led by Major Nathaniel Terry marched for Boston.

In 1781, Mother Ann Lee, leader of a new religious group that later became known as the Shakers, visited Enfield for the first time. She and her followers were dragged into the street and threatened with tar and feathering. Ann Lee escaped town with the help of Elija Jones, a Revolutionary War officer. During her second visit to Enfield in 1782, she was again attacked by a mob. A local constable named John Booth broke up the riot, and the attackers were prosecuted and fined by the county court in Hartford. This act ended resistance to Shakerism in Enfield. In 1783, Ann Lee visited Enfield for the last time, this time without interference from hostile mobs. Five years later, a Shaker community was established in the northeastern part of town. The community quickly grew to 250 members in five separate settlements, or "families," covering 3,000 acres before the end of the Civil War; the community then declined and dissolved by the early 1900s.

In 1828, Orrin Thompson established the first carpet mill on Freshwater Brook in Enfield. Over the next century, the carpet industry grew into a huge complex of mills that employed thousands and produced some eight million yards of carpet each year. The village that grew up around the mills was named Thompsonville, for the founder of the carpet industry in Enfield. Like the Shaker community, the carpet industry in Enfield eventually failed. Rising labor costs and obsolete facilities forced the last mill to close in 1971.

In 1835, Allen Loomis began operating a small black powder mill on land he purchased in Powder Hollow. The next year, he and several partners incorporated as Loomis, Denslow and Company. In 1837, Augustus Hazard acquired one-quarter interest in the firm. He became the driving force behind the gunpowder industry in Enfield and, like Orrin Thompson, had the village that grew around his industry named after him. At its zenith during the Civil War, the Hazard Powder Company covered hundreds of acres and produced tons of black powder each day for the Union. After the war, the company survived decades of decline before ending with a bang on January 14, 1913, when a major explosion ended further production at the plant.

These and many other events shaped Enfield and set the stage for this book. The images that follow show Enfield from the late 1800s through the mid 1900s—years when the carpet and gunpowder industries were active, if not thriving. The towns of Enfield, Thompsonville, Hazardville, and Scitico were separate villages, and each had its own very distinct character.

One

ENFIELD

THE VILLAGE AND THE STREET

Stretching along Enfield Street (Route 5) from Route 190 to the southern end of town, the village of Enfield is the oldest part of today's Town of Enfield. The historic homes and buildings that line both sides of the street comprise Enfield's Historic District. Enfield's first settlers, John Pease Jr. and Robert Pease, dug a shelter into the side of a hill where they spent the winter of 1679–1680 before bringing their families the following spring. That same year, a score of other families joined them. John Pease Jr. was a surveyor by trade, and he undertook the job of laying out the town's streets and plat in 1680. The first known map of Enfield, drawn at that time, shows the land that he granted to the early settlers lining both sides of today's Route 5, from Freshwater Brook to the East Windsor town line.

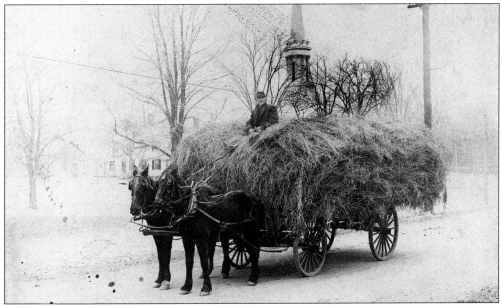

Times were changing when this load of hay passed the Congregational church on Enfield Street c. 1900, with Joseph Pierce at the reins. Electricity and telephone services were well established even though horse-drawn transportation remained the standard. The church still stands at the corner of South Road today, but horses and wagons seldom pass this way. (EHS Collection.)

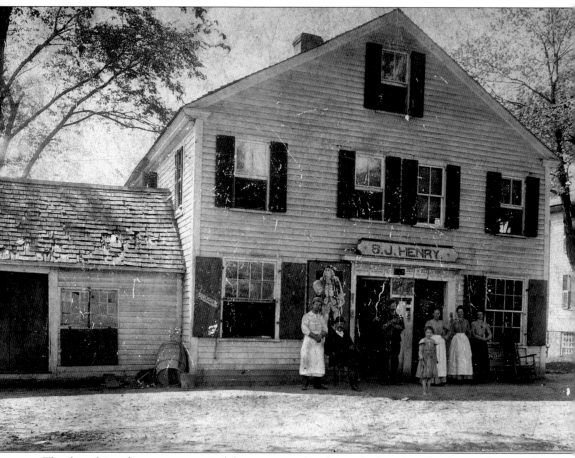

The first thing that comes to mind for most people when asked to describe the southern end of Enfield Street is the stretch of beautiful homes lining the street. Usually forgotten are the businesses that have been scattered among the homes in the area. Pictured above is B.J. Henry's store, located at 1436 Enfield Street. It remains a popular neighborhood store but is no longer owned or operated by the Henry family. Longtime residents of Enfield will remember it as Hartley's store. The extension at left no longer exists. (EHS Collection.)

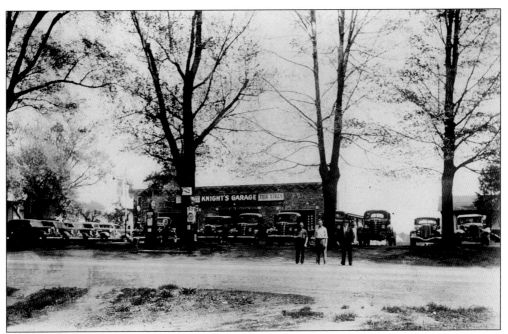

Knight's garage was located on the east side of Enfield Street, just south of the intersection with Post Office Road. The building has undergone extensive remodeling and today houses medical offices. (EHS Collection.)

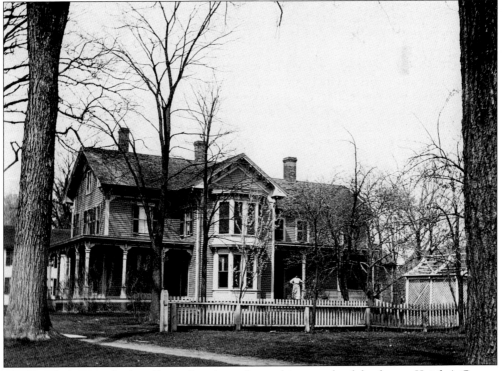

The Knight home, which still stands today, is located just north of the former Knight's Garage building. (EHS Collection.)

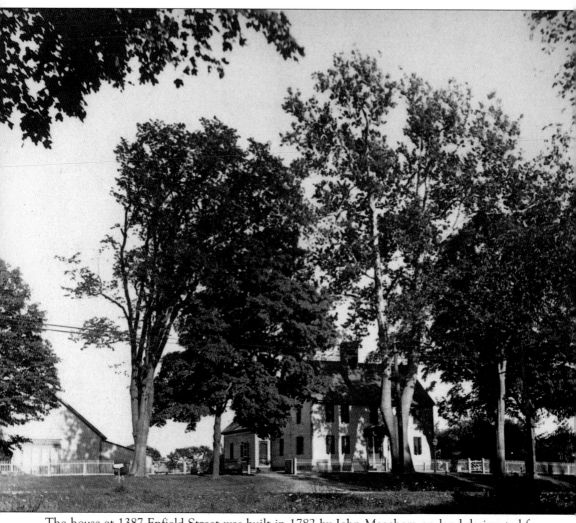

The house at 1387 Enfield Street was built in 1782 by John Meacham on land designated for use as a parsonage. Another Meacham named Joseph was the first male leader of the United Society of Believers, known today as the Shakers, when the Society was established in 1792. He was responsible for codifying the Shakers' beliefs and rules.

In 1800, John Meacham's house was purchased by John Ingraham, a retired sea captain from Saybrook, Connecticut. His granddaughter married Simeon Parsons. Their granddaughter, Martha A. Parsons, left the house and its contents to the Enfield Historical Society, which now operates the house as the Martha A. Parsons House Museum.

For many years, the house was known as Sycamore Hall because of the trees that lined the street in front of it. Those trees can be seen dwarfing the house in the picture above. (MAP Collection.)

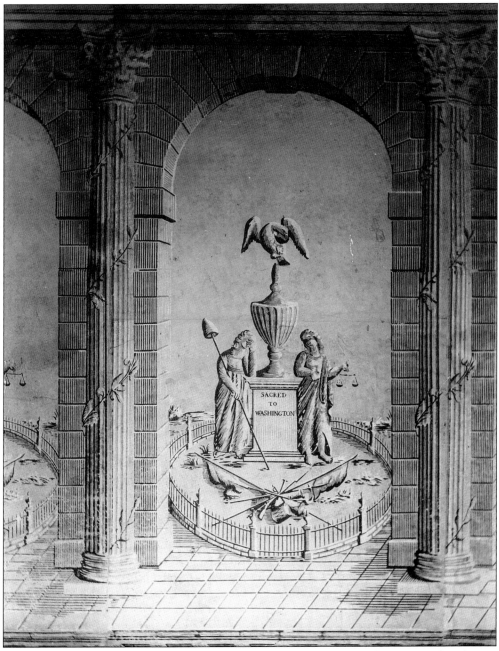

A Boston paper stainer combined the English pillar and arch design with a memorial to George Washington. His advertisement for the wallpaper declared "[as the wallpaper is created] to perpetuate the Memory of the Best of Men, is the production of an American, both in draft and workmanship, it is hoped that all true-born Americans will so encourage the Manufactories of the Country, that Manufactories of all kinds may flourish, and importation stop." Today, nearly 200 years after it was hung, the last of this paper to be found hanging in any home still decorates the front hallway of the Martha A. Parsons House Museum. (MAP Collection.)

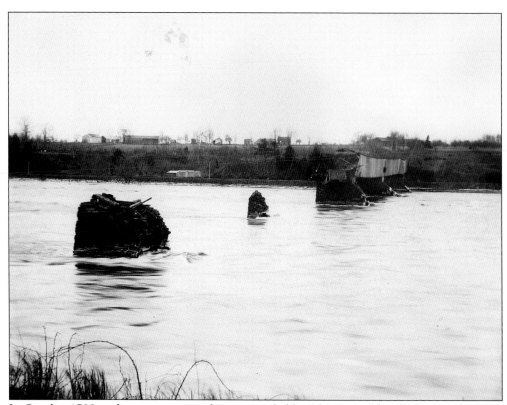

In October 1798, a charter was granted to a group led by John Reynolds, which gave them the right to build a bridge across the Connecticut River from Enfield to Suffield. It also enabled group members and their heirs to collect tolls on the bridge for either a period of 100 years or until they collected the cost of the bridge plus 12 percent. This bridge, the first across the Connecticut River in Connecticut, was completed c. 1808. Built without a roof or walls to protect it from the harsh New England weather, it quickly deteriorated and had to be replaced after it collapsed in 1821. In a preview of today's state lotteries, the new bridge, completed in 1832, was financed by a lottery.

The new covered bridge proved to be much more enduring than the first bridge, although it did eventually come to a spectacular end, as seen in this view. On February 14, 1900, flood waters from the rising river threatened to destroy the bridge. Authorities of the New York, New Haven, & Hartford Railroad feared that if the bridge collapsed, the debris would damage the railroad bridge 2 miles down the river at Warehouse Point. Hosea Keach, an agent for the railroad at Bridge Lane Station, was assigned the task of watching the bridge and sending a warning when the bridge was near collapse. At about 2 p.m., he went out onto the bridge. As he neared the end of the first span, three spans, including the one he was on, collapsed into the river. Somehow Hosea scrambled up into the timber framing at the top of the span, where he found himself sitting on a beam with his feet dangling over the rushing water. Luck continued to be on his side, and using a piece of lumber he was able to punch a hole through the roof that was large enough to climb through. In one last bit of good fortune, two railroad employees at the Warehouse Point bridge, Arthur Blodgett and R.A. Abbe, saw Hosea and lowered a rope from the railroad bridge as the span he was on floated underneath it. He was pulled to safety wet but uninjured.

The remainder of the bridge was demolished for scrap; it took three charges of dynamite to collapse it completely. All that remains of the bridge are small islands where the bases of the piers were located. (Hilditch Photo Collection.)

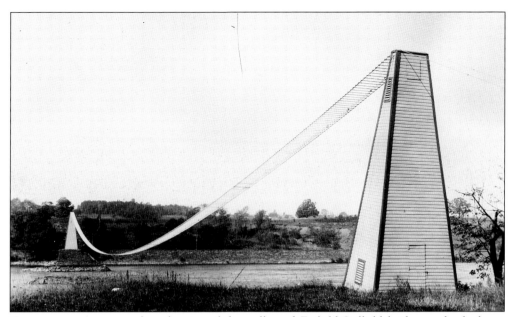

Two towers were erected at the site of the collapsed Enfield-Suffield bridge, and telephone cables were strung across the river, supported by a catwalk. The Enfield tower was 32 feet tall and the Suffield tower, over 800 feet away, was 43 feet tall. The cables were manufactured by Roebling & Company of New York. Only the foundation for the Enfield tower remains. (Hilditch Photo Collection.)

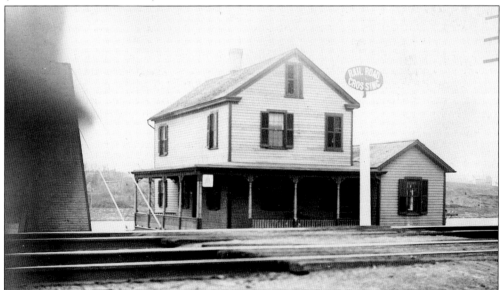

The house at the end of Bridge Lane was the site of the first telephone exchange in Enfield. Note the telephone tower visible at left. The small extension on the right was originally the toll booth for the covered bridge. The house was framed with materials from the first (1808) bridge at the site. During the Civil War, it was the home of U.S. Senator James Dixon, who was a friend of Abraham Lincoln. After serving as the telephone exchange, the house was part of the Enfield Farms duroc hog farm. It has recently been restored as a private residence. (Hilditch Photo Collection.)

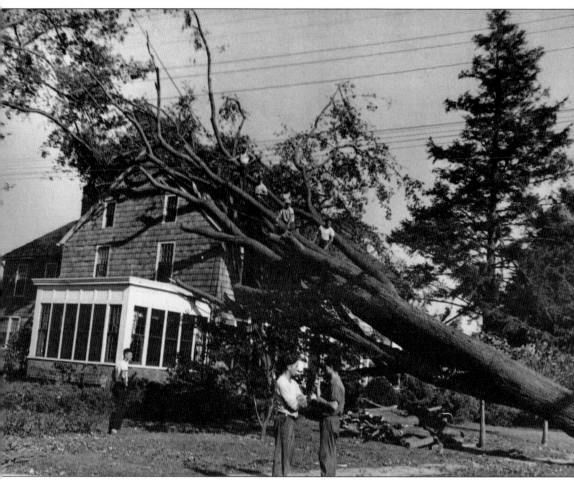

The hurricane of 1938 brought destruction to all parts of Enfield. The eye of the storm passed 10 to 20 miles to the west of Enfield, bringing high winds that caused a great deal of damage in the town. Many trees were blown over, closing streets and damaging buildings, including the house on the corner of Bridge Lane and Enfield Street. Built in 1763 by Dr. Simeon Field, the house at 1346 Enfield Street was identified on Smith's Map of Hartford County, published in 1855, as Abbe's Hotel. The building served as an inn or tavern until the early 1900s, when it became known as the Old Lion Hotel. It is presently a private residence. (EHS Collection.)

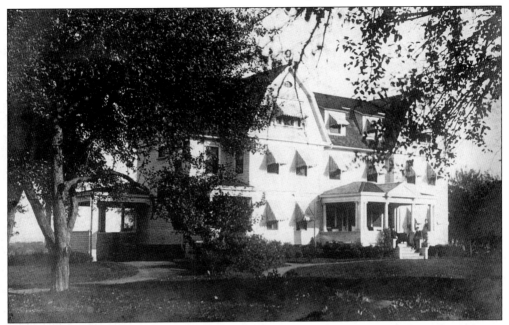

Dr. Vail's Sanatorium was established by Edwin Smith Vail, M.D., in 1890 on the 100-acre grounds at 1165 Enfield Street. Patients were given "modern" treatments including "hormone treatments," for nervous, mental, alcohol, and drug problems. They stayed in either rooms or suites, depending upon their needs and financial means. Outdoor sports, movies, and "occupational recreations" were available for their amusement. Edwin's son, Thornton, also an M.D., was superintendent of the facility before it closed. The sanatorium closed c. 1940, at which time the building and grounds became the Elmcroft Inn. The inn was advertised at the time as "famous for its food," and people were encouraged to "dine, lunch, have tea or stay." Later it became the Parkway Inn. The building was torn down to make room for condominiums.

About 1910, Dr. Edwin Vail was honored at a meeting of the Connecticut Society of Alienists and Neurologists, where he presented a paper he had written titled "The Evil of Over Pressure in Our Schools." A quote from the paper reads as follows: "Every student of child-nature knows that at about the thirteenth year the child becomes a youth surprisingly fast. Physically they can not endure long strains of bodily or mental effort; they do not always break, they wilt, and are liable sooner or later to develop into neurasthenic men and women. An education that provides a child simply with desk work, to the exclusion of physical exercise, or an education that taxes a child too much in one direction, such as music or drawing, are also attended by grave dangers. The absurd and often cruel custom of forcing prolonged musical training, requiring many hours of daily practice, upon children who have no special musical talent, and who have in addition the other tasks of school to perform, is only too common in this country." What would Dr. Vail say about today's young athletes?

Dr. Thornton Vail, in addition to his work at the sanatorium, maintained a private practice. Between 1911 and 1948 he delivered more than 5,000 babies. (MAP Collection.)

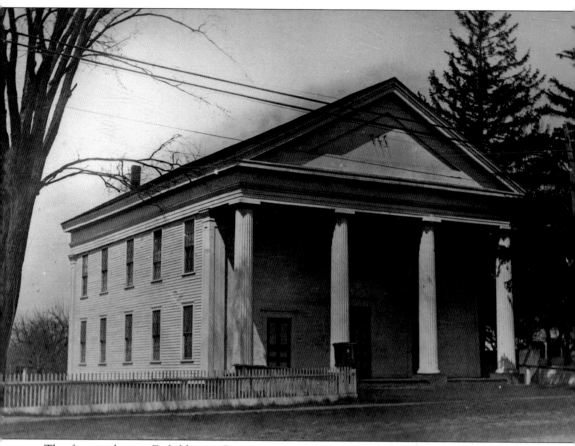

The first settlers in Enfield were Puritans, most of whom came from Salem, Massachusetts. They built their first meetinghouse, a small log structure, in 1683 near the present Enfield Street Cemetery. In 1704, a second, larger meetinghouse was built farther south, on Enfield Street across from Post Office Road. Nothing remains of either church, although the site of the second house is marked with an engraved boulder.

By the early 1770s, the second meetinghouse was no longer large enough to meet the needs of the town, so construction began on the third meetinghouse. The newest church was dedicated January 1, 1775. Months later, on Thursday, April 20, 1775, a rider arrived with news that fighting had broken out near Boston. Many of the town's residents were attending services at the church, so Thomas Abbey, the town drummer, pounded his drum while circling the meetinghouse to rouse the congregation. This was the start of the American Revolution for Enfield.

After 70 years of use, the third meetinghouse was in need of repair. In 1844, the congregation voted to build a new one, which was completed in 1849. The old church building was sold to the town for use as a town hall. Workers using teams of oxen moved the building a few yards to the west side of Enfield Street. Major changes to the building, including removal of the steeple and construction of a portico, were completed at that time.

The building had many uses over the next 100 years, including as a community hall and as a fire station, but it was not well maintained. In 1972, major restoration of the badly deteriorated and condemned building was undertaken by Enfield Historical Society volunteers. After nine years of hard work, the restoration project was completed in 1981, and the building reopened as the Old Town Hall Museum. The Old Town Hall is listed on the National Register of Historic Places. (EHS Collection.)

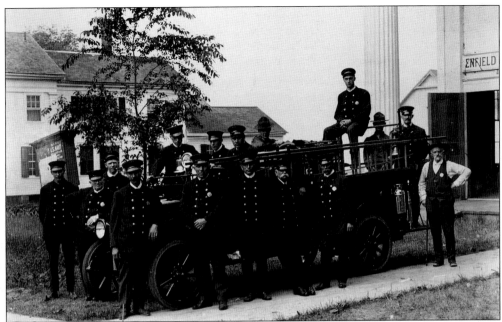

This 1917 photo shows the Enfield Fire Department when it was housed in part of the building. The hose tower from the fire station can still be seen in the Old Town Hall Museum today. Among the notices posted on the billboard behind the fireman on the far left is a recruiting poster for the U.S. Navy. The house on the left still stands but is separated from the Old Town Hall by the fire station that was built in 1955 and closed in 1997. (EHS Collection.)

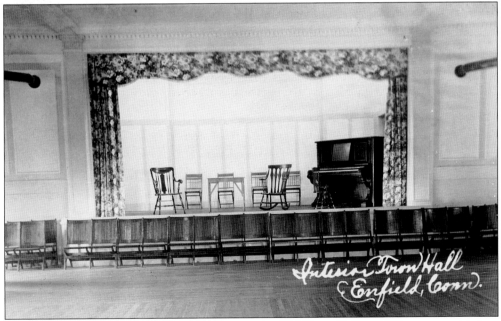

The Enfield Community Association took over the Old Town Hall in 1923, converted it into a community house, constructed a stage on the second floor, and opened it to the public on February 22, 1924. Plays, recitals, and movies at the hall have entertained many people over the years. (MAP Collection.)

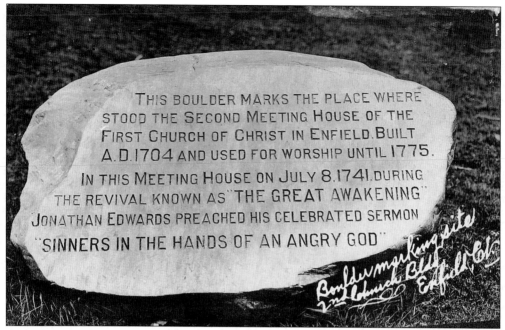

THIS BOULDER MARKS THE PLACE WHERE STOOD THE SECOND MEETING HOUSE OF THE FIRST CHURCH OF CHRIST IN ENFIELD. BUILT A.D. 1704 AND USED FOR WORSHIP UNTIL 1775. IN THIS MEETING HOUSE ON JULY 8.1741. DURING THE REVIVAL KNOWN AS "THE GREAT AWAKENING" JONATHAN EDWARDS PREACHED HIS CELEBRATED SERMON "SINNERS IN THE HANDS OF AN ANGRY GOD"

An important sermon preached by Jonathan Edwards in 1741 at the Congregational Meeting House in Enfield is commemorated by a stone monument on Enfield Street. Postcards showing this monument were common in the early 1900s.

In the mid-1800s, a major religious revival known as the "Great Awakening" took place. One of the leaders of that movement was Jonathan Edwards. On July 8, 1741, he preached his internationally known "Sinners in the Hands of an Angry God" sermon at the second meetinghouse of what is today the Enfield Congregational Church. The following excerpts from the 15-page sermon show why it is considered one of the most intense "fire and brimstone" sermons of all times: "For these the wrath of God is burning; the pit is prepared, the fire is ready, the furnace is hot, the flames do rage and glow . . . And there is no reason to be given why those sitting in the presence of the preacher have not dropped into hell since they have been sitting here, but the unobliged forbearance of an incensed God . . . And it would be no wonder if some, in health and quiet and secure, should be there before tomorrow morning."

The Reverend Stephen Williams of Longmeadow, Massachusetts, attended the sermon. In his diary he wrote the following account: "We went over to Enfl—where we met dear Mr. E. of N.H., who preached a most awakening sermon from Deut 32,35, and before sermon was done there was a great moaning and crying through ye whole House, what Shall I do to be Sav'd—oh, I am going to Hell—oh, what shall I do for Christ., &c., &c., so yt ye minister was obliged to desist, ye shrieks and crys were piercing and amazing—after Some time of waiting, the congregation were still, so yt a prayer was made by Mr. W. and after that we descendd from the pulpitt and discoursed with the people—Some in one place and Some in another—and Amazing and Astonishing ye power of God was Seen—and Several Souls were hopefully wrought upon yt night, and oh ye cheerfulness and pleasantness of their countenances yt received comfort—oh yt God wd strengthen and confirm—we sung a hymn and pray'd and dismiss'd ye Assembly." (MAP Collection.)

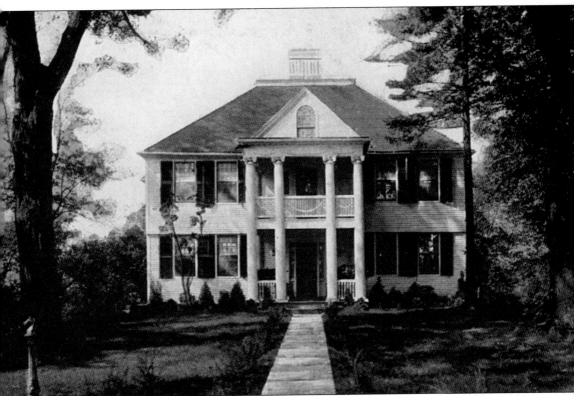

Ephriam Pease, a wealthy Enfield landowner, built this mansion on Enfield Street in 1769 for his 14-year-old daughter, Sybil, as a wedding present. Sybil's husband, the Reverend Elam Potter, was the Congregational minister at the third Meeting House, which is now the Old Town Hall Museum. The Reverend Potter was adamantly opposed to slavery and was removed from the pulpit for voicing his views. He was said to have operated an Underground Railroad "station" from this house. His father-in-law Ephriam was a slave owner and lived next door in the house that many people will remember as "the old Anderson house." The topic of slavery must have caused lively discussions between the two. The Potter mansion burned in October 1977 and was replaced with a less elaborate but similar building. Ephriam Pease's house was recently renovated and enlarged. (MAP Collection.)

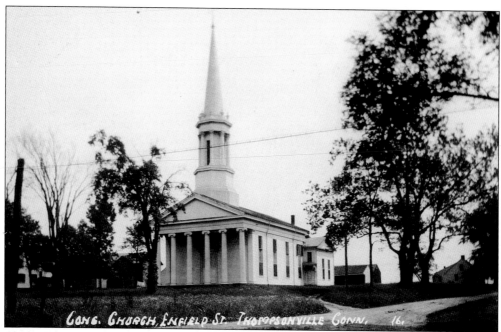

The Enfield Congregational Church, located at the corner of Enfield Street and South Road, was dedicated on February 14, 1849. It was the fourth meetinghouse for Enfield's First Ecclesiastical Society. (MAP Collection.)

On November 4, 1916, the Captain Thomas Abbey Memorial was dedicated in front of the Enfield Congregational Church. The memorial was to commemorate the captain's famous drum march around the third meetinghouse (the Old Town Hall Museum) announcing the outbreak of the Revolutionary War. (Member Collection.)

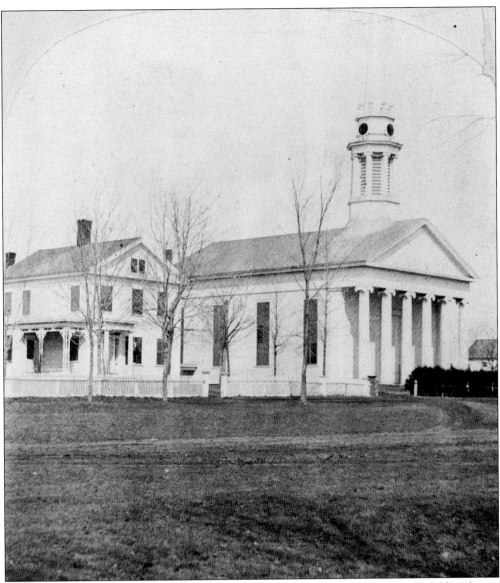

In 1855, about one-half of the congregation split from the Enfield Congregational Church in a dispute over religious practices. Two years later, they built the North Church on Enfield Street, at the spot now occupied by the entrance to Enfield High School. The new church was short-lived, as many of the members drifted back to the original church, and the rest joined other churches. It closed in 1878 and was sold one year later to the Catholic Apostolic Church. The Catholic Apostolic Church was somewhat more successful until it eventually closed and was torn down c. 1929. (MAP Collection.)

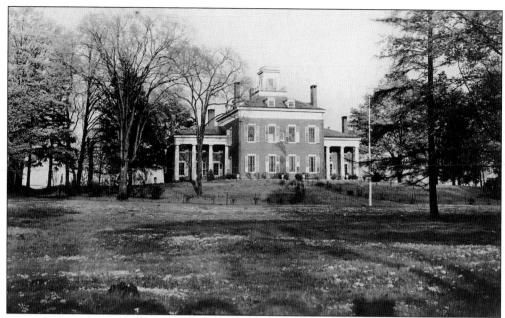

Orrin Thompson, founder of the Thompsonville Carpet Company, built his mansion Longview on Enfield Street in 1832. It was later owned by G. Harrison Mifflin of the Houghton-Mifflin publishing company of Boston. Finally, in 1933, the Felician Sisters purchased the mansion and 32 acres of land around it and founded Our Lady of the Angels Convent. (MAP Collection.)

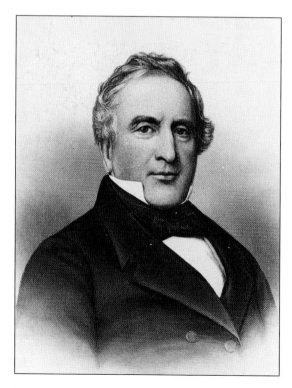

Orrin Thompson was born on March 28, 1788, in Suffield, Connecticut, but grew up in Enfield. In 1828, he founded the Thompsonville Carpet Manufacturing Company on Freshwater Brook. His business grew rapidly and so did the mill town, which was also named for him. Thompson's business was hit by a major slump in the late 1840s, and in 1851 Thompson and his son went bankrupt. The business was purchased by a group of investors from Hartford and was reborn in 1854 as the Hartford Carpet Company. Orrin Thompson was hired as superintendent of the mills that he had previously owned; he served in that position until 1861. The carpet industry continued to flourish in Thompsonville under several names and owners until 1971, when the Bigelow-Sanford Carpet Company's operations ceased. Thompson's name and memory, however, survive. (EHS Collection.)

Col. Augustus Hazard's mansion was located on Enfield Street, across from the entrance to the current Enfield High School. Hazard and his wife entertained many important persons in this home, including businessmen such as Samuel Colt and politicians such as Secretary of War Jefferson Davis (who later became President of the Confederate States of America). For many years, the mansion was operated as the Enfield Inn. It was destroyed by fire while undergoing renovations in January 1969. (Member Collection.)

Col. Augustus Hazard was the founder of the Hazard Powder Company and the namesake for the village of Hazardville. Augustus Hazard was born in South Kensington, Rhode Island, in 1802. At the age of 20, after working five years as a house painter, he moved to Savannah, Georgia, and became a dealer in paints and oils. A very successful businessman, he moved to New York and became partial owner of a line of packet ships that operated between New York and Savannah. Gunpowder was one of the products carried regularly by his ships. A financial panic in 1837 came close to destroying him financially, but he repaid all of his debts and survived the panic with stronger credit than ever. That same year, he acquired one-quarter interest in Loomis, Denslow, and Company, a gunpowder manufacturer in Enfield. His holdings in that company increased until 1843, when the Hazard Powder Company was incorporated. (Hilditch Photo Collection.)

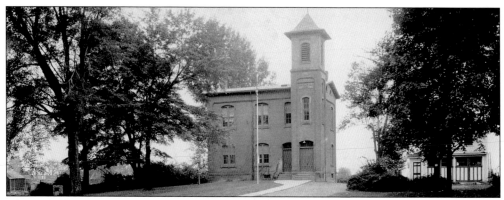

The Enfield Street School District was established in 1708. In 1869, to meet the demands of Enfield's growing population, the district's existing wooden schoolhouse was torn down to make room for the construction of a two-story, brick school. Even though it was very modern for its time, the new school did not have indoor toilets until they were installed in the basement in 1911. The school was located in front of the current Enfield Street School. The site is marked by a bronze plaque mounted on a large stone. (EHS Collection.)

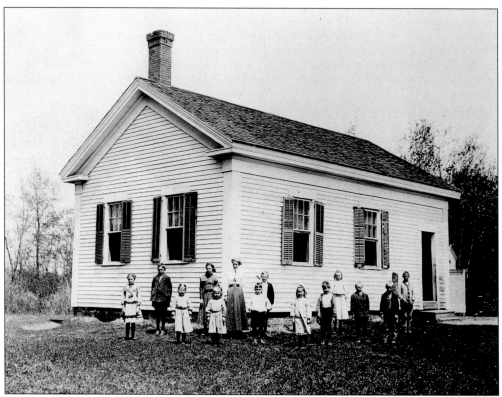

The Weymouth, Jabbock, and London school districts were established in 1775. The Weymouth School was located on Weymouth School Road. Pictured are the students who attended the school during the 1909–1910 school year along with their teacher, Mary E. Bridge. (Member Collection.)

Two

THOMPSONVILLE
THE CARPET CITY

The village of Thompsonville got its name in 1828, when Orrin Thompson built his first carpet mill on Freshwater Brook. Although there had been farming and grazing activity in the area around Freshwater Brook as early as 1653, and John Pynchon had operated a sawmill on the brook in 1674, there were only about 50 people living in the area when it became Thompsonville. Driven by the rapidly expanding carpet industry, however, Thompsonville soon became the most populous and urban section of Enfield. Other industries were attracted to Thompsonville, some to support the carpet industry, others simply to take advantage of the village's location, railroad, and large pool of skilled labor. Even today, decades after the last carpet mill closed and most of the other industry has left, Thompsonville still retains its mill town character.

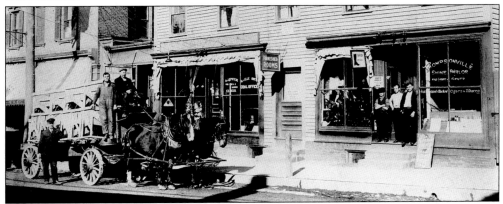

This photograph of businesses on Main Street in Thompsonville was taken *c.* 1912. The store in the building at left belonged to William S. Chestnut, "stationer and newsdealer," who published many postcards of Enfield during the first two decades of the 20th century. The building at right housed several businesses, including the office of A.J. Epstein Express movers. The Epstein wagon parked in front of the office was loaded with Singer sewing machines; one can be seen in the window to the right of the horses' heads. Smyth's Coal office shared the same entrance with Epstein Express. The Thompsonville Shine Parlor "for Ladies and Gents" occupied the store on the right. Shoes, shoe repairs, hat cleaning and blocking, cigars, and tobacco were all available in the Parlor. Furnished rooms were available for rent upstairs. (EHS Collection.)

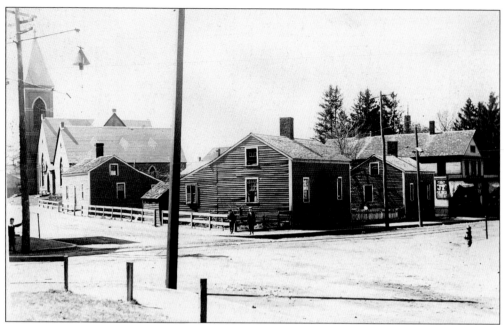

Prior to 1899, early mill housing occupied the northeast corner of South Main Street and High Streets. Rapid commercial growth along South Main Street (presently the northern end of Pearl Street) brought major changes to the corner, as these photographs illustrate. (Hilditch Photo Collection.)

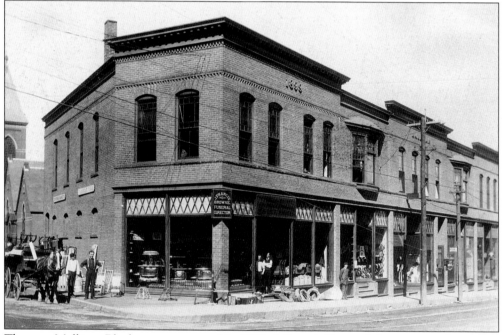

The new Mulligan Block was constructed in 1899. J. Francis Browne's business was located in the corner storefront. Browne sold coal stoves and ranges and also worked as a funeral director. The tracks of the Hartford & Springfield Street Railway Company passed in front of the building. (Hilditch Photo Collection.)

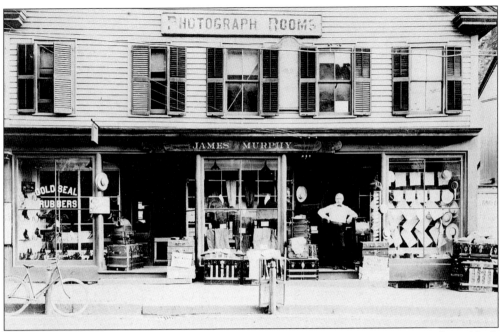

James Murphy's store was located in the "old" Mulligan Block, south of the new Mulligan block on South Main (Pearl) Street. (EHS Collection.)

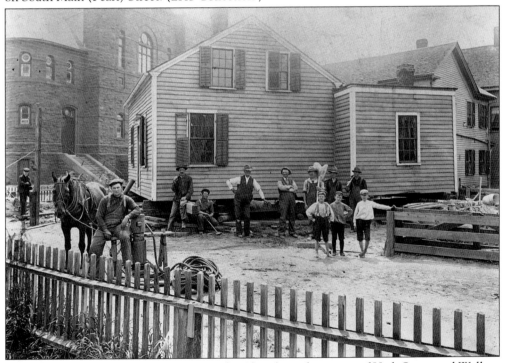

The house across the street from St. Patrick's Church, at the corner of High Street and Wallace Street, was moved to make way for a building constructed for Charles Brainard in 1909. The first Thompsonville telephone exchange was located in the second floor of the new building. (EHS Collection.)

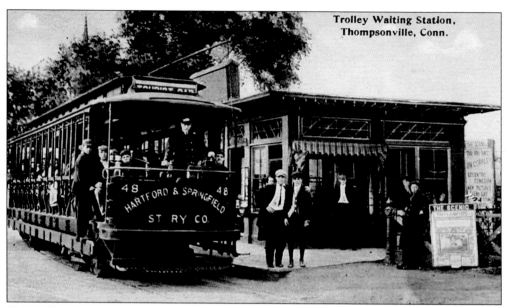

The trolley waiting station was located near the dam on Freshwater Pond. The Hartford & Springfield Street Railway Company operated the trolleys that stopped regularly at the station, transporting thousands of passengers daily at its peak. Trolley service started on Thanksgiving Day, 1896, when the Enfield & Longmeadow Electric Railway Company made its first run from Thompsonville to Longmeadow, Massachusetts. The station became a bus depot after the Hartford & Springfield went bankrupt in 1926 and trolley service ended. (MAP Collection.)

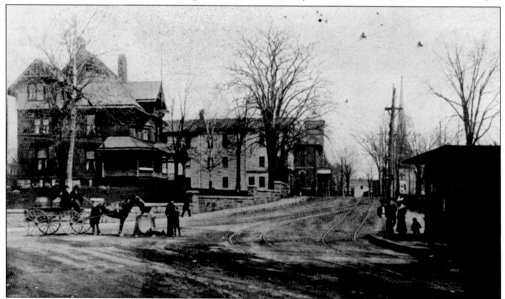

In this view, looking north on North Main Street from its intersection with Main and South Main Streets, the Lyman Upson mansion can be seen on the left, and the trolley waiting station is visible on the right. Note the passing track that allowed trolleys to travel in opposite directions on the same line. When this *c.* 1900 postcard was published, trolleys and horse-drawn transportation still had a few years of operation before automobiles and trucks took over the road. (MAP Collection.)

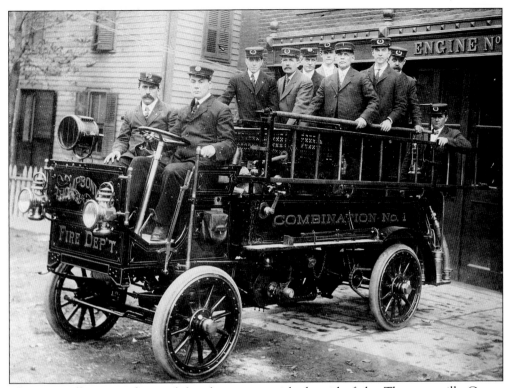

Thompsonville got its first real fire department with the aid of the Thompsonville Carpet Manufacturing Company after fire destroyed the company's dye house in June 1834. Fires were a constant threat in those days, and stockholders voted to finance a fire department. The old Thompsonville fire station still stands on Pearl Street, just north of the current fire station. It has been extensively remodeled over the decades, but the old hose/bell tower still stands over the building.

Thompsonville's first fire truck was manufactured by the Knox Automobile Company of Springfield, Massachusetts. Money for the truck was appropriated in 1907, and the contract with Knox was signed one year later. The truck's arrival was celebrated with a parade through Thompsonville. Combination No. 1 was a combination chemical truck with a capacity of one 35-gallon chemical tank and two 3-gallon fire extinguishers. It carried 200 feet of chemical hose and 500 feet of water hose, one 13-foot ladder and one 24-foot extension ladder. It was designed to carry six firefighters, although most pictures show eight or more men crowded on the truck.

There is an interesting story told about this fire truck. When the fire bell rang, all of the children in the neighborhood would rush down to the fire station. The object was not to watch the fire truck speed away. The two-cylinder truck did not have enough power to climb the hill on which the station was located unaided. The children were needed to push the truck to the top of the hill! (Hilditch Photo Collection.)

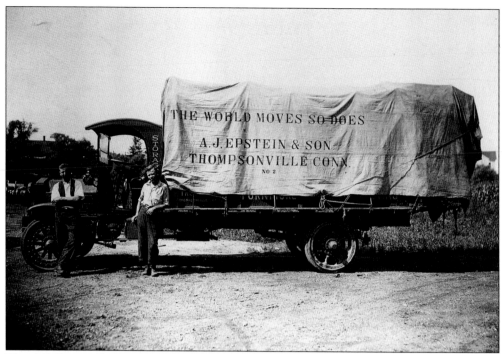

The A.J. Epstein & Son's moving and storage company's trucks were garaged near Freshwater Pond. This 1919 photograph shows one of their early trucks. (EHS Collection.)

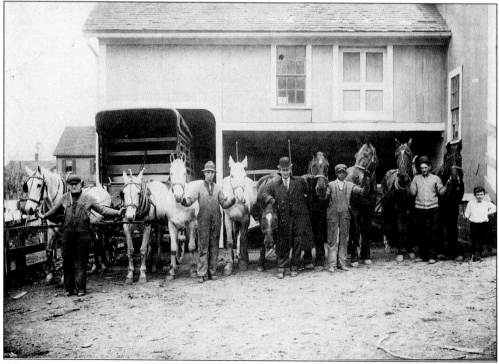

A.J. Epstein & Son was not the only hauling business in Thompsonville. The employees and horses of Harry Smyth's Express Company pose for the camera in this photo. (EHS Collection.)

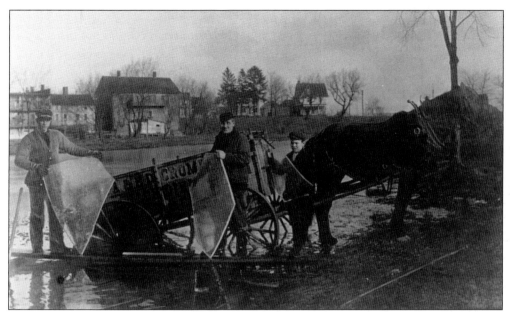

The P.A. & H.D. Crombie Klondike Ice Company was located on Freshwater Pond. An unidentified worker, Peter A. Crombie Sr., and Francis Crombie Sr. at age 11, are collecting ice on Freshwater Pond in this c. 1915 photo. North Main Street is in the background. (Crombie Photo Collection.)

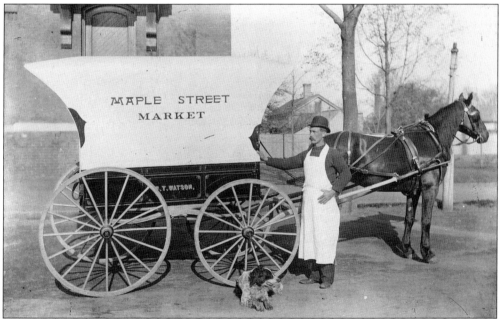

In the 1800s and early 1900s, the section of Enfield Street (Route 5) between High Street and Alden Avenue was called Maple Street. North of Alden Avenue, it was called Springfield Road. William T. Watson was 29 years old when he opened this butcher shop/grocery store at the northern end of Maple Street in March 1890. This photograph was probably taken shortly after the opening. The store was moved during the 1890s to the corner of Asnuntuck and Prospect Streets. Watson operated the business until his death in 1940. (Member Collection.)

The northern-most section of Pearl Street, from North Main Street to High Street, was once a part of South Main Street. This *c.* 1880 photograph was taken looking south along South Main Street from its intersection with Main Street. The first building at left was Dixon's boardinghouse, and the next was Savage's boardinghouse. The building at the end of the street was John O'Hear's grocery store. It was located at the present site of St. Patrick's Church, which was built beginning in 1889 and dedicated in 1904. (MAP Collection.)

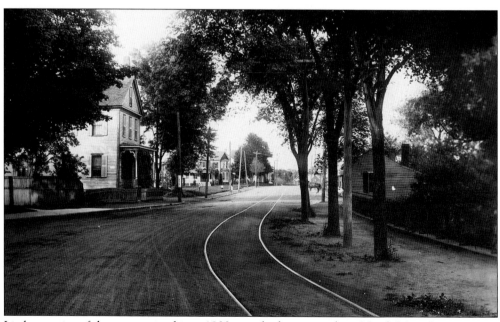

Little remains of the scenery in this *c.* 1900 view looking east along North Main Street except for the house at left. Formerly the Midnight Spa, the recently restored building now serves as an optician's office. Freshwater Pond is just out of view on the right. (Hilditch Photo Collection.)

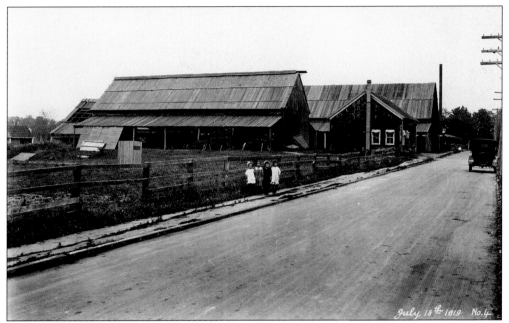

In 1905, the Henry D. Alden brickyard, located on the north side of Alden Avenue, was sold to Lewis K. Brower of Suffield and his son-in-law, John A. Best, of Albany, New York. Production at the brickyard reached 40,000 bricks per day the previous year. This 1919 photograph is a view looking east, past the Brower & Best brickyard, toward Enfield Street. (EHS Collection.)

The Alden Avenue Ballpark was located slightly west of the Brower & Best brickyard. The ballpark hosted both local teams and exhibition games by visiting professional teams. The new construction in the foreground is housing on Bigelow and Hartford Avenues for carpet mill employees. The housing development quickly displaced both the ballpark and the farms around it. (EHS Collection.)

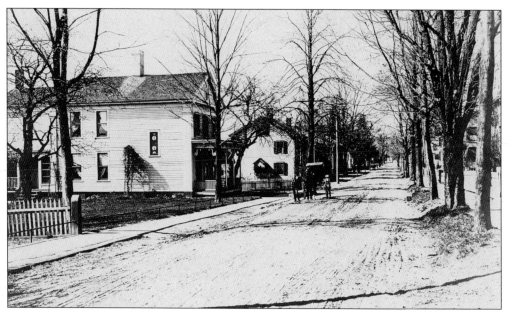

Carpet mill expansion frequently fueled housing booms in Thompsonville. New houses were often in the way of later mill expansion. In this view looking north along Pleasant Street, the houses at left were moved or torn down when the 1,000-foot-long Tapestry Mill was built by the Hartford Carpet Corporation in 1901. (Hilditch Photo Collection.)

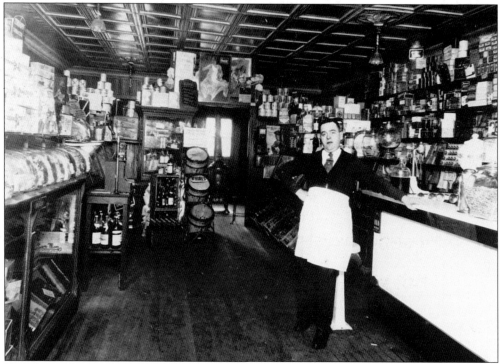

Fred Leander is seen in his Pleasant Street store in this 1930s view. Mr. Leander had almost infinite patience when it came to waiting for children to pick out penny candy. (Member Collection.)

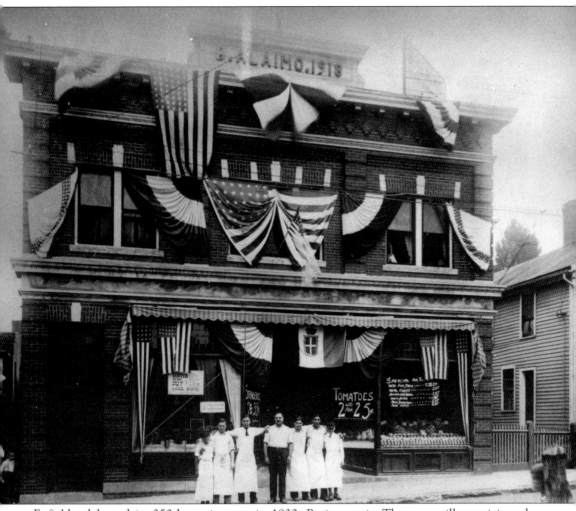

Enfield celebrated its 250th anniversary in 1930. Businesses in Thompsonville participated in the celebration by displaying elaborate patriotic decorations like those on Benny Alaimo's store on Whitworth Street. Tony DiLeo, Dominick Lepore, Vincent Leone, Benny Alaimo, Matty Alaimo, Frank "Red" Siano, and Joe Alaimo are seen posing in front of the store. (Member Collection.)

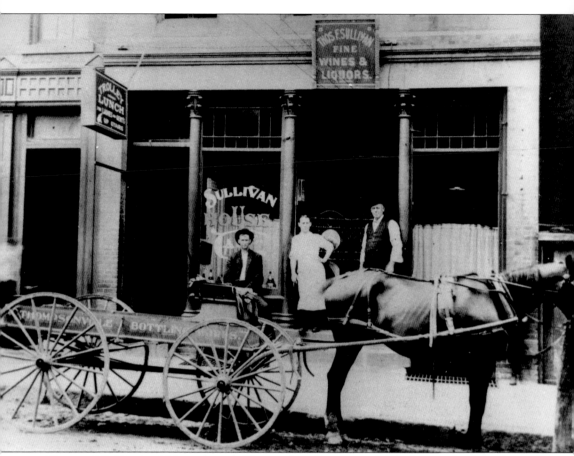

Thomas F. Sullivan sold fine wines and liquors from his store on Main Street, which was located across from the Hartford Carpet Company mill complex. A quick meal could be had at the Trolley Lunch upstairs. In the 1920s, the building became the Greys Club. The horse and wagon in this *c.* 1900 photograph belong to the Thompsonville Bottling Works on Enfield Street. (Member Collection.)

Winters in the late 1800s and early 1900s were considerably colder and snowier than they are today. Wagons and carriages were put away until the snow melted. Sleighs and cutters ruled the roads. The horses in this *c.* 1880 photograph of Main Street were covered with blankets to protect them from the cold. The tall building at right is the Thompsonville Hotel. Hartford Carpet Company mill buildings can be seen in the distance. The ghost-like bell tower is on the black mill. Only the S. Parsons building and the tall Greys Club building behind it survive today. (MAP Collection.)

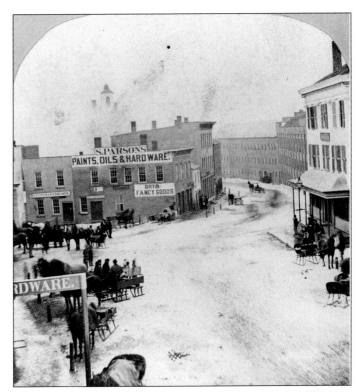

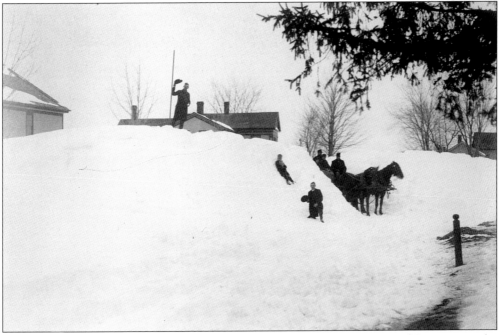

The worst snowstorm to hit Thompsonville—and much of the eastern United States—was the blizzard that began on March 12, 1888. Worse than the snowfall, which was measured in feet in many places, were the drifts that often reached rooftops. This photograph is a view of North Main Street at the approximate location of the present Enfield Town Hall. (EHS Collection.)

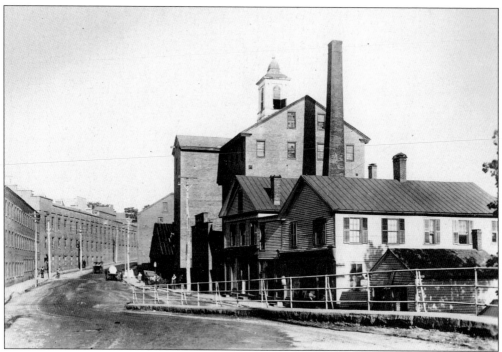

The Hilditch Block was located on the south side of Main Street, between the railroad tracks and the Black Mill. Built in 1826, the block was the site of the first place of worship, the first high school classes, the first post office, the first grocery store, the first clothing store, the first firemen's meetinghouse, and the first drum corps meetinghouse in Thompsonville. This photograph was taken c. 1892, when the black mill was razed. The Hilditch Block was torn down in 1951. (EHS Collection.)

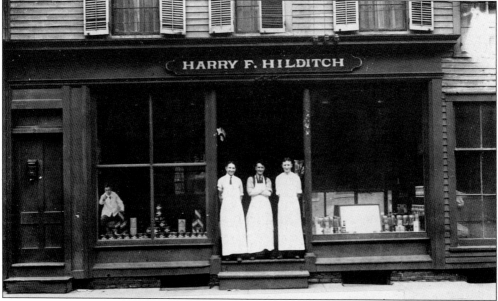

Harry Hilditch's employees stand in front of his Main Street store in this c. 1900 view. (Hilditch Photo Collection.)

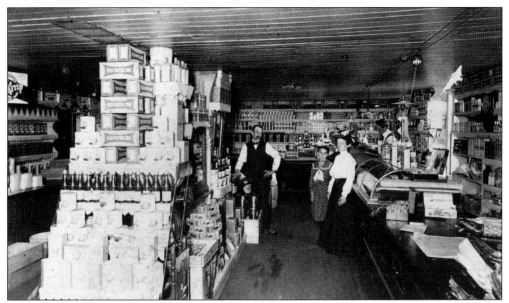

Harry Hilditch's Main Street store was well stocked, as this *c.* 1900 photograph shows. (Hilditch Photo Collection.)

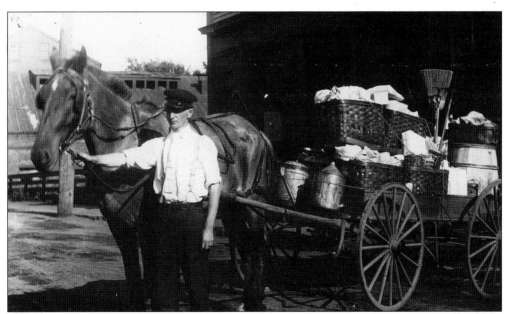

In this *c.* 1892 photograph, Harry Hilditch poses with his loaded delivery wagon. Each customer's order was carefully packed into a separate basket. The Hartford Carpet Company dye house can be seen in the background, but the Black Mill, which was razed in 1892, is noticeably missing. (Hilditch Photo Collection.)

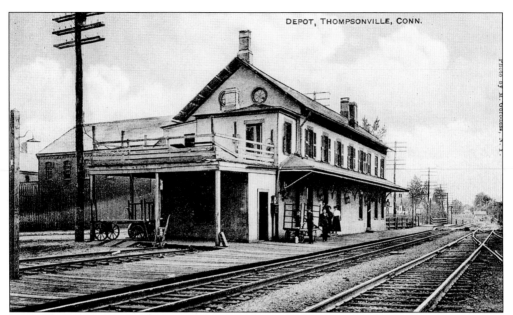

The railroad depot in Thompsonville predated many of the familiar carpet mill buildings. The station master lived above the station. It is said that his wife would hang the wash out to dry and then have to rewash it after soot and cinders from passing steam trains settled on the wet clothes. The station was torn down after many years of neglect and vandalism. (MAP Collection.)

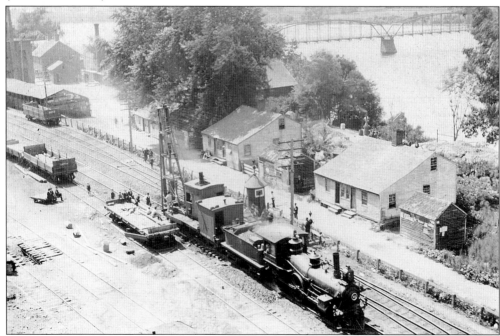

Wooden railroad ties and heavily traveled rails required constant maintenance. This maintenance train was photographed near the Thompsonville railroad depot *c.* 1900. North River Street is seen along the west side of the tracks. The iron bridge between Thompsonville and Suffield, completed in 1893, is visible in the background. (EHS Collection.)

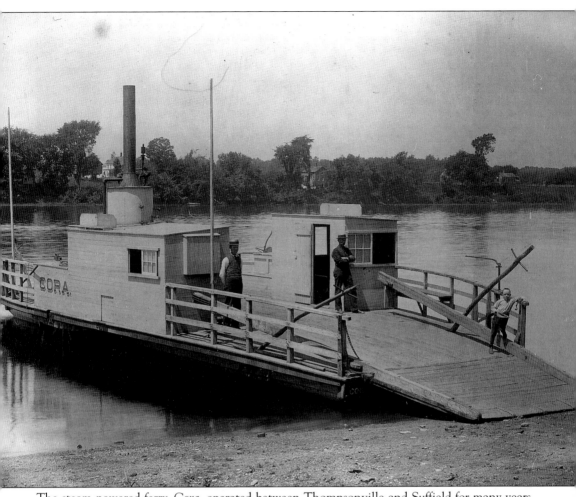

The steam-powered ferry, *Cora*, operated between Thompsonville and Suffield for many years prior to completion of the iron bridge between the two towns in 1893. The boat and ferry rights were owned by Watson W. Pease and Servillius A. Griswold of Suffield. After completion of the bridge between Thompsonville and Suffield, the ferry saw only limited use along the Connecticut River until the bridge connecting Hartford and East Hartford burned. The ferry was sold to businessmen from Hartford, who operated it there until the completion of a temporary bridge to East Hartford. *Cora* was then resold, this time to businessmen in Westerly, Rhode Island. (EHS Collection.)

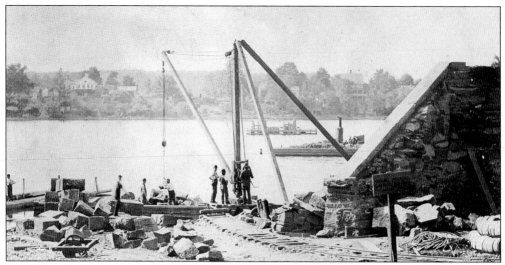

In 1889, a charter was granted to the Suffield and Thompsonville Bridge Company to construct an iron bridge across the Connecticut River between Thompsonville and Suffield. The Berlin Iron Bridge Company of Berlin, Connecticut, was hired to construct the bridge, and O.W. Weand of Reading, Pennsylvania, was awarded the contract for the foundations, piers, and abutments. Ground was broken at the end of Main Street for the Thompsonville abutment on August 15, 1892. Thaler & Hall Co. of Portland, Connecticut, supplied most of the stone. Some stone also came from quarries in East Longmeadow and Somers. A total of 6,000 tons of stone were used to construct the bridge. (EHS Collection.)

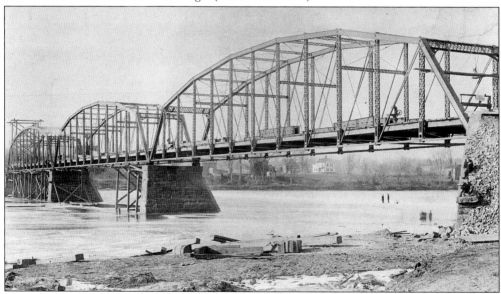

Construction of the 1,060-foot-long bridge continued through the winter. In the 1890s, winters were very cold, and the Connecticut River froze over solid enough to allow the workmen to build staging for construction of the bridge on top of the ice, as seen in this photograph. The last of the five iron spans was completed on Saturday, January 14, 1893. That day, Lizzie Furey became the first woman to cross the bridge. The last deck plank was laid the following Friday, and a two-horse team from the Hartford Carpet Company, driven by James Boyle and packed with passengers, made the trip from Thompsonville to Suffield and back. (EHS Collection.)

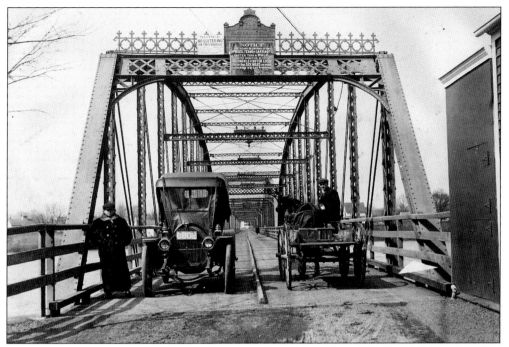

On February 20, 1893, the bridge officially opened when Nathan Hemenway became its first toll-taker. Tolls on the bridge were 3¢ for pedestrians, 12¢ for single teams, and 15¢ for double teams. The bridge was demolished in 1971, and all that is left are the piers and abutments and the cast iron signs from the ends of the bridges. Many of these artifacts are preserved in the collections of the Enfield and Suffield Historical Societies. This photograph shows Dr. Alcorn's car and Arthur Davison in Hilditch's grocery wagon. (Hilditch Photo Collection.)

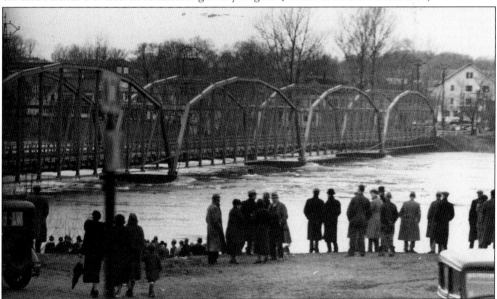

The Thompsonville-Suffield bridge was threatened by the flood in the spring of 1936, but it managed to survive another 35 years. This photo, like the other three, is looking toward Suffield. (EHS Collection.)

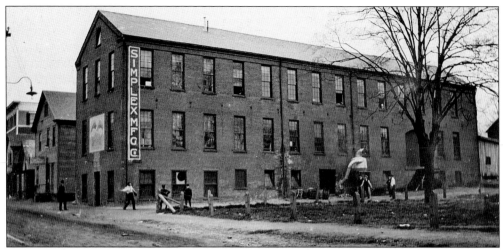

The Simplex Manufacturing Company on Asnuntuck Street manufactured a variety of products, including machines for sealing envelopes and rolling coins. The men in white shirts are wearing baseball gloves and playing catch in this 1909 postcard, which was published around the time Simplex moved to Thompsonville. Before Simplex moved into the building, it was part of the Stockinet Mill complex and, later, the Hartford Carpet Company. Through the years, the building housed a number of other businesses. It was owned by a VFW post when it was torn down in 1998. During the demolition, evidence of a water turbine used to power machines was found, and the tail race leading to Asnuntuck Brook was left for future archaeologists to study. (MAP Collection.)

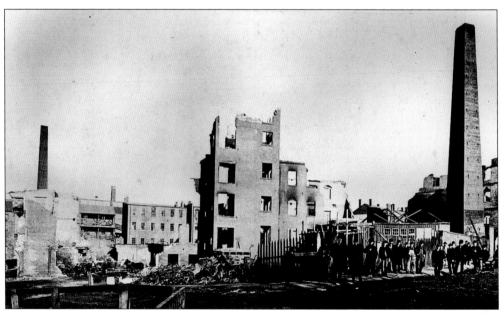

The Enfield Manufacturing Company was founded by Orrin Thompson's son, Henry Grant Thompson, in 1845. Commonly called the Stockinet Mill, the company made hosiery and underwear until it failed in 1873; its Asnuntuck Street buildings were then sold to the Hartford Carpet Company. The largest building became the Wool House. It was destroyed by fire c. 1887. (Hilditch Photo Collection.)

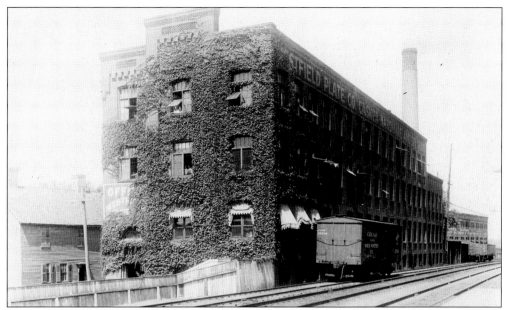

The Westfield Plate Company's plant was built in 1893 on North River Street, across the tracks from the Thompsonville railroad depot. Casket hardware, shrouds, and linings were manufactured at the plant. The company went out of business in 1958, but the building still stands. The Hartford Carpet Company power plant's tall smokestack is seen in the background at right. (Hilditch Photo Collection.)

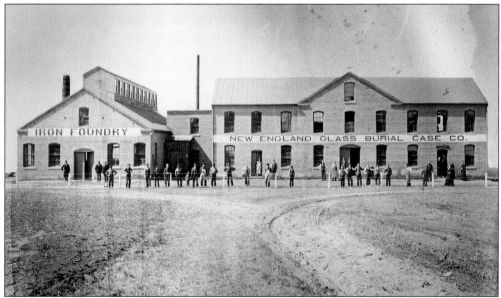

One of a number of businesses started during the late 1870s and early 1880s, the New England Glass Burial Case Company manufactured glass caskets at this factory on Prospect Street. The G.H. Bushnell Press Company's iron foundry is seen at left. G.H. Bushnell, founded in 1887, manufactured a variety of heavy machinery ranging from hydraulic presses to carpet looms for the Upson-Martin Carpet Company. G.H. Bushnell moved out of Enfield in 1922. The building, which was later enlarged, is still in use today by other businesses. (EHS Collection.)

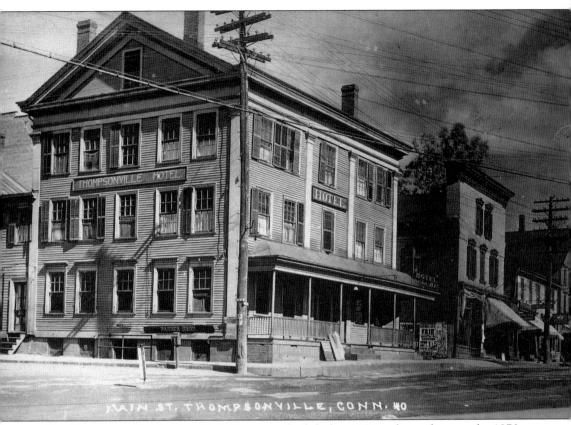

The Thompsonville Hotel on Main Street was built before 1820 and torn down in the 1970s, as part of Thompsonville's urban renewal project.

Dr. James Naismith, inventor of the game of basketball, stayed at the hotel on November 21, 1893, along with his team, a volleyball, and a peach basket. The team was in town to demonstrate the game of basketball to the Hartford Carpet Company workers. The hotel register with Naismith's signature can be seen today at the Old Town Hall Museum.

For decades, the hotel was the location for the Fourth of July firecracker pitching activities. It is said that by nightfall, Main Street was filled with firecracker papers piled deep enough to overflow the high granite curbing.

For many years Pete Giorgiola's barber shop was inside the hotel building. During the Great Depression, he cut hair on credit, keeping a list of those who owed him. His customers paid him back when they were able. It took ten years for the last customer to pay, but Giorgiola collected every penny owed. He was very proud of the fact that people thought enough of him to pay such old bills without being asked. Pete Giorgiola's barber pole, smock, and barber tools are in the collection of the Enfield Historical Society. (MAP Collection.)

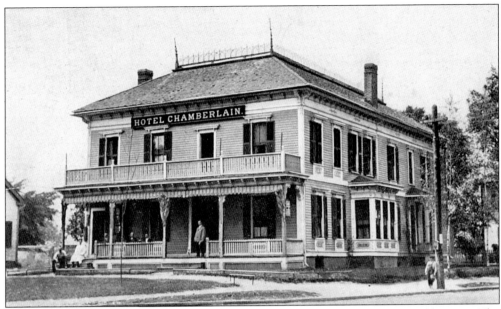

The Hotel Chamberlain stood on the corner of North Main Street and Enfield Street. The hotel closed and the building was converted to house stores and apartments. Space for the stores was added at that time by raising the entire building and constructing the new first floor underneath the existing two floors. The building was torn down in the 1970s. (MAP Collection.)

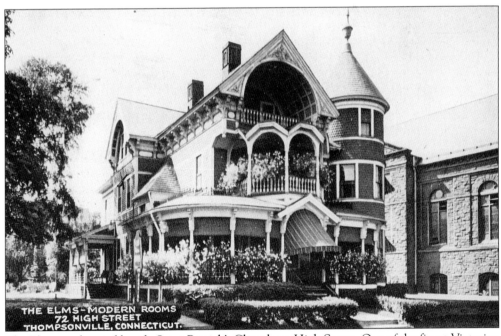

The Elms was located beside Saint Patrick's Church on High Street. One of the finest Victorian houses in Enfield, it was built by the Sullivan family, who owned the livery stables that supplied horses and carriages to all visitors arriving by train in Thompsonville. (MAP Collection.)

The Mountain Laurel Restaurant was located on Enfield Street in Thompsonville for many decades. The carpeting in the dining rooms was specially designed and woven by the Bigelow-Sanford Carpet Company for the restaurant and featured Connecticut's state flower, the mountain laurel. In the 1940s, one of the restaurant's spring culinary delights was Connecticut River shad, caught by area children who gratefully received 25¢ for each fish. The building presently houses professional medical offices. (MAP Collection.)

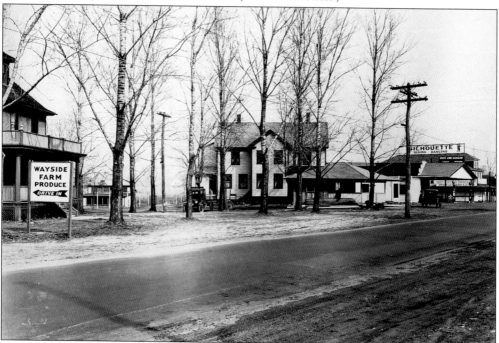

Big bands played North Thompsonville's Silhouette club in the 1930s and 1940s. Many wedding receptions and other banquets were held there over the years. The smaller open building attached to the house in front of the Silhouette was the popular Terwilliger's hamburger stand for many years. Route 5 continued north into Longmeadow at right, as seen in this March 11, 1930 view. (EHS Collection.)

50

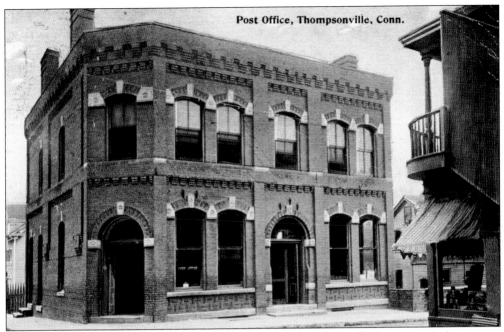

The post office on the corner of Asnuntuck and Prospect Streets was built in 1914. In later years, it housed the library, the Thompsonville Trust Company, and a youth center. It was demolished during the 1970s urban renewal project. (MAP Collection.)

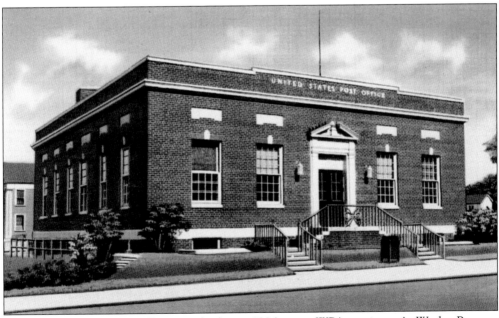

The High Street Post Office was built in 1936 as a WPA project. A Works Progress Administration mural of Thompsonville hung in the lobby until the new post office opened on Palomba Drive. The mural was cleaned and moved to the new post office, where it remains on permanent display. The old post office is currently a postal storage facility. (MAP Collection.)

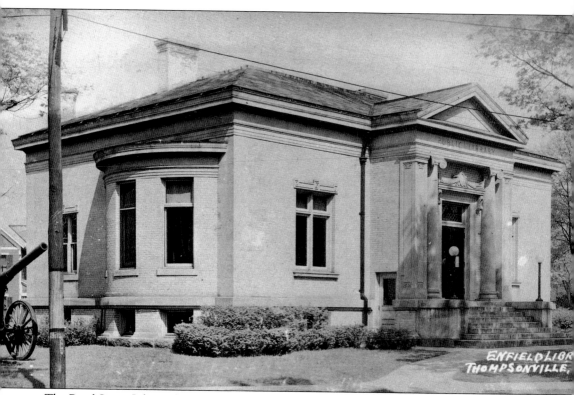

The Pearl Street Library, located at the corner of Franklin Street, was dedicated on February 27, 1914, and opened on May 5, 1914. Andrew Carnegie donated $20,000 for construction of the library—with only one catch. The town had to vote to provide an annual maintenance budget for the library equal to one-tenth the amount of his donation. The original vote had been for $1,250 per year for maintenance, which Carnegie had agreed to match with $12,500 for construction. A later vote was taken to raise the annual budget to $2,000, and Carnegie agreed to provide $20,000. Of this donation, $8,400 was spent on masonry work, $8,000 on carpentry, and the remaining $3,600 on furnishings. The town also raised $1,915 in donations to pay for the land on which the library was built. The library was recently completely restored.

This photograph was taken some time after 1920, when the cannon at left was dedicated. The cannon was a German 77 that had been captured at the Battle of Argonne. It was dedicated on Armistice Day, November 11, 1920. The cannon was broken up and used for scrap during World War II. (MAP Collection.)

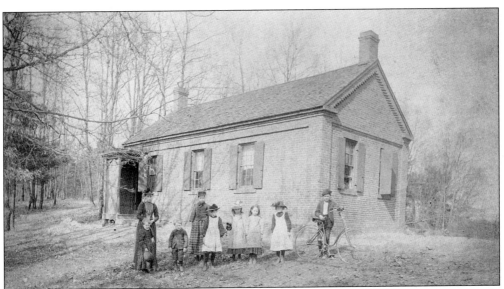

The Brainard School District was established in 1792 on Brainard Road. In this 1893 photograph, Herbert Chilson is seen standing with his bicycle. (EHS Collection.)

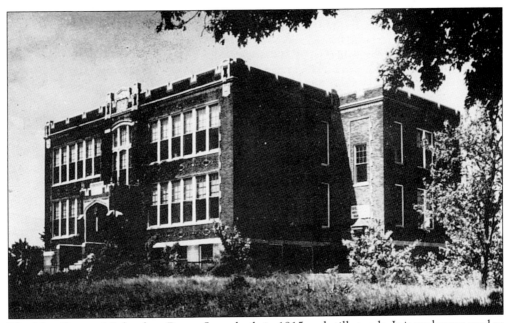

The New Brainard School on Route 5 was built in 1915 and still stands. It is no longer used as a school building. (MAP Collection.)

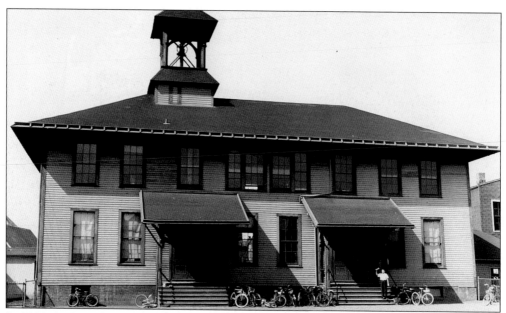

In 1882, St. Patrick's Church purchased an abandoned six-room public school and moved it to the site of what is now the St. Patrick's Church parking lot. This was the second school building occupied by St. Joseph's School. It was used until 1958. (St. Patrick's Church Collection.)

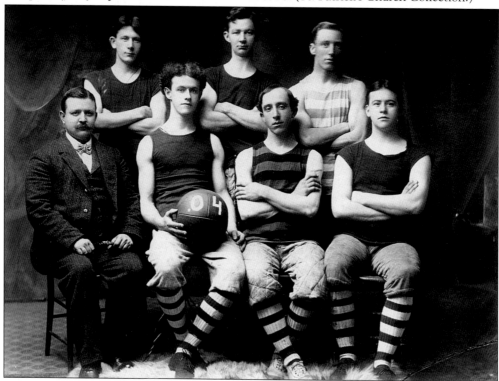

The St. Joseph's School 1904 basketball team was managed by Joseph Sloan (seated at left). From left to right, team members are pictured as follows: (seated) Eddie Collins, Jack Malley, and "Lip" Stone; (standing) Pat Fahey, Charlie McCue, and Eddie Lyons. (EHS Collection.)

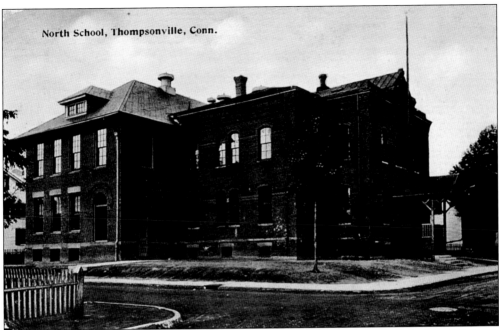

North School, Thompsonville, Conn.

In 1860, Thompsonville had three two-room wooden schools: the Bell School, the North School, and the South School. The town's rapidly growing population necessitated the replacement of all three schools with larger, brick schools. The North School building still stands today but is no longer a school. (Member Collection.)

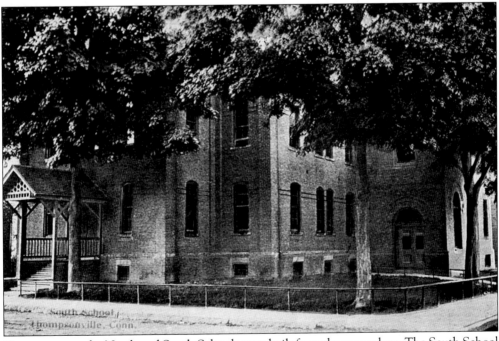

South School, Thompsonville, Conn.

To save money, the North and South Schools were built from the same plans. The South School was torn down in February 1979. (Member Collection.)

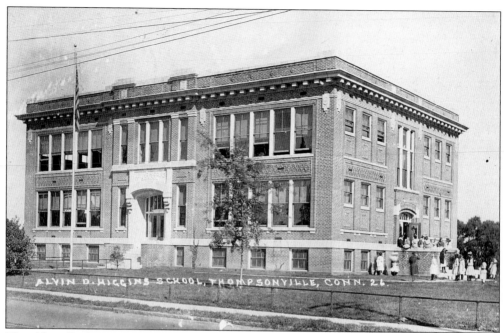

The Alvin D. Higgins School was named for the Hartford Carpet Corporation agent who provided the land on which the school and the town hall are built. This early photograph shows the school as it was originally built in 1914. The size of the school doubled in 1921 when an exact duplicate of the original school was added to the east end of the building. (MAP Collection.)

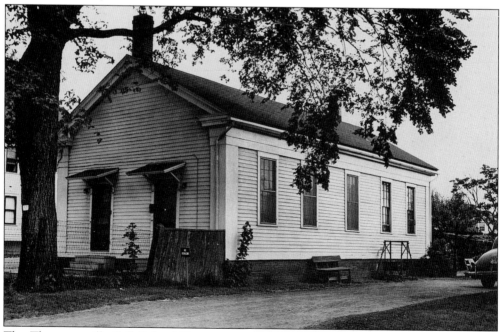

The Thompsonville Bell School District was established in 1750. The Bell School on Elm Street, pictured here as it appeared in the 1940s, was built in the early 1800s. It is presently a private residence. (EHS Collection.)

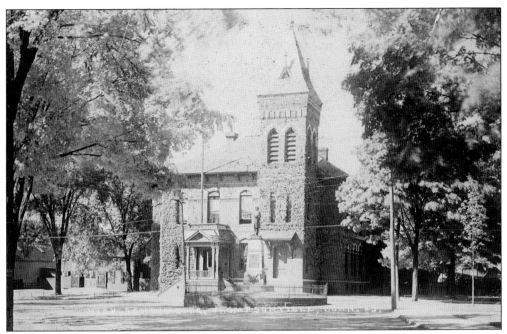

Enfield's first high school was built in 1868 on North Main Street in Thompsonville. Prior to its construction, high school students were taught in separate classes in the other schools. In later years, the building was used as a center school, courthouse, police station, and finally, a youth center. It was torn down during the 1970s urban renewal project. (MAP Collection.)

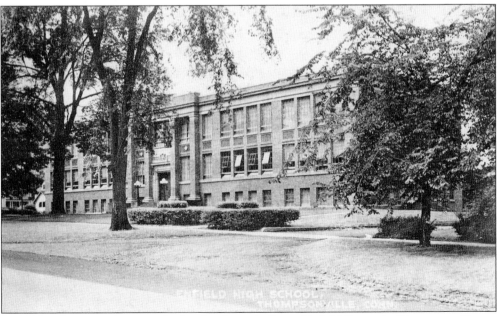

In 1925, a larger replacement high school was built on Enfield Street in Thompsonville, on land donated by Dr. Thomas Alcorn. The building was recently restored and enlarged and is now the Thomas Alcorn Elementary School. (MAP Collection.)

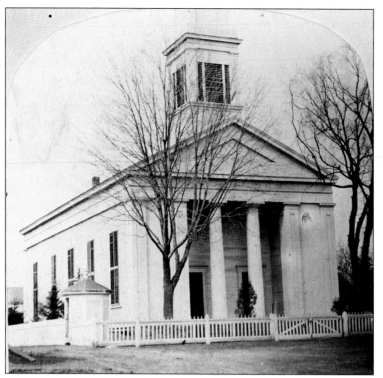

In 1840, the First Presbyterian Church building was constructed by Orrin Thompson on the corner of Church and North Main Streets for the Scottish weavers he brought over to work in his carpet mills. (MAP Collection.)

The First Presbyterian Church building was expanded in 1845, 1859, and again in 1875. After that, it remained virtually unchanged for 100 years until 1971, when a new church was built on King Street. The old church was demolished as part of the 1970s urban renewal project.

The town's Civil War monument stood in front of the church, and the trolley tracks ran past the front door. All that remains today is the monument, which was moved a few yards to the west during the 1970s urban renewal project. (Hilditch Photo Collection.)

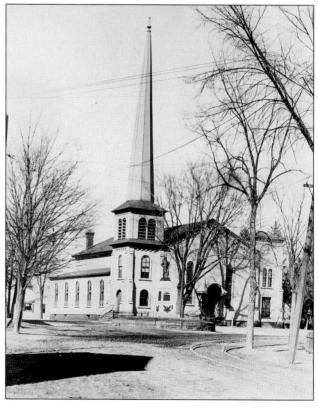

The United Presbyterian Church was organized in 1845 by members who broke from the First Presbyterian Church due to a disagreement over the use of an organ during services, which the First Presbyterian Church considered sinful. Their first church was built on the corner of Pleasant and School Streets on property purchased for $1 from the Thompsonville Carpet Manufacturing Company. The deed carried with it a clause that required the property to be returned to the company when expansion became necessary. The time came 55 years later, when the church was torn down for construction of the new tapestry mill in 1901. (Hilditch Photo Collection.)

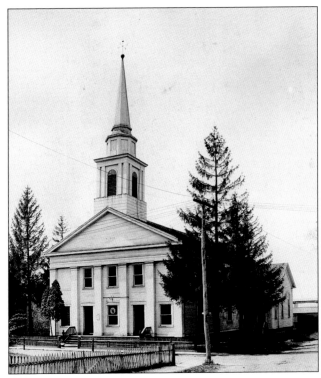

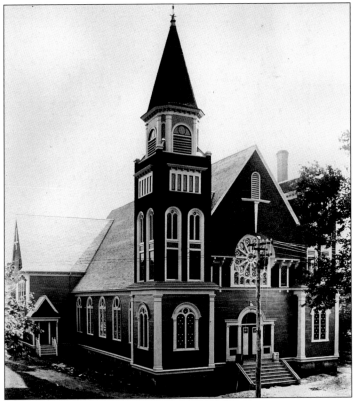

When the property on which their original church stood was reclaimed in 1901 by the carpet company, the members of the United Presbyterian Church built a new building on High Street. The building was severely damaged by fire in 1943 but was repaired and continued to serve the congregation until 1973, when the membership became part of the Calvary Presbyterian Church on King Street. The building is presently used as a senior citizens center. (Hilditch Photo Collection.)

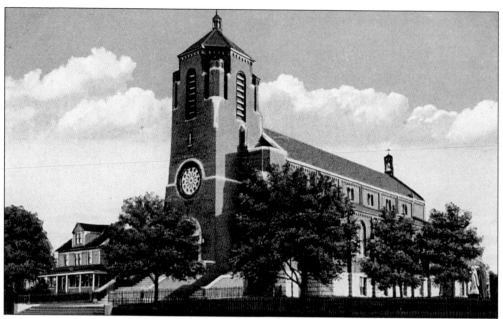

Saint Adalbert's Roman Catholic Church, located on Alden Avenue, was established in 1915 by Polish immigrants. At first, only the basement level was used, with a simple roof overhead. The church was completed over the next ten to 12 years. (MAP Collection.)

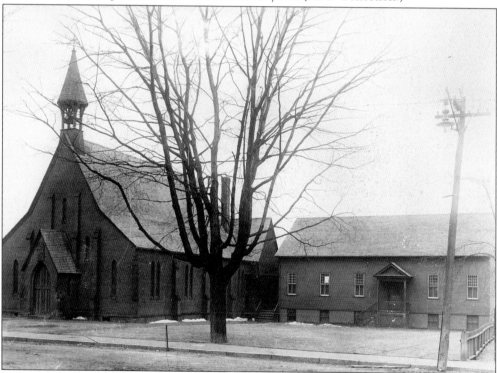

The cornerstone for Saint Andrew's Episcopal Church on Prospect Street was laid in 1858, and the parish house was built in 1902. The church remains much the same today as when it was built, and it continues to serve its congregation well. (Hilditch Photo Collection.)

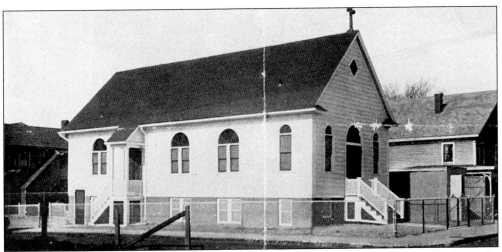

Saint Nicholas's Greek Orthodox Church was dedicated on Sunday, October 25, 1925, on the site of the old Orpheum Theater. The theater served as a church for eight years before it burned down. (Thomas P. Arvantely Collection.)

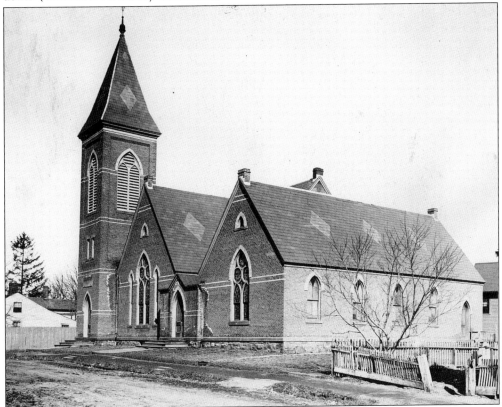

The Thompsonville Methodist Church was organized in 1841. Services were first held in the Bell School on Elm Street. The first church built by the congregation was located on High Street, east of Pearl Street. Pictured is the second church building, built in 1884 on High Street, west of Pearl Street. In 1964, another new church was built on Brainard Road, and the old brick church was sold to the Amvets, who still use it today. (Hilditch Photo Collection.)

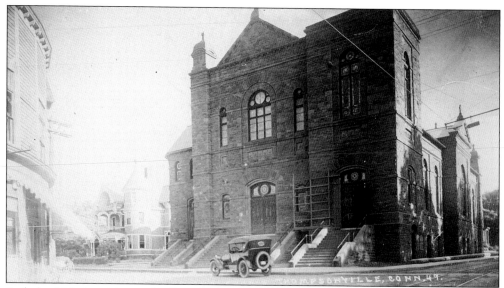

Built by Irish immigrants, St. Patrick's Roman Catholic Church, located on the corner of Pearl and High Streets, was dedicated in 1904. At that time, the Irish experienced harsh discrimination. The parishioners were forced to find an Irish architect to design the church because no one else would provide them the service. This turned out to be very fortunate, as the church was designed by Patrick Charles Keely, who designed 700 churches and 21 cathedrals in his career. Because of the influx of Italian immigrants into Thompsonville, Masses in Italian were conducted in the basement of the already crowded church in the early 1900s. (MAP Collection.)

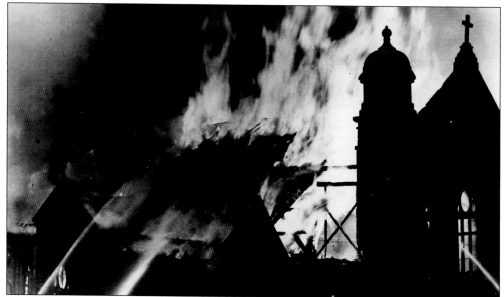

On January 5, 1949, St. Patrick's Church went up in flames—the result of a fallen candle. Firefighters could do little except try to keep the flames from spreading to surrounding buildings. All that was left was the brownstone shell of the building. Reconstruction began almost immediately, and the rebuilt church was rededicated on November 19, 1950. (Hilditch Photo Collection.)

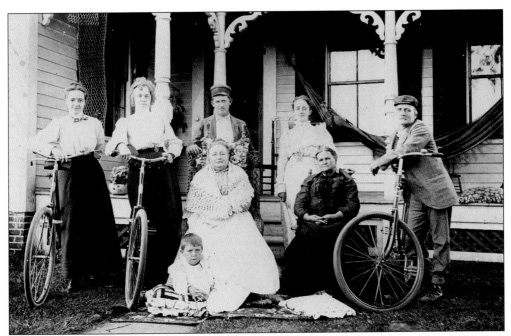

In this *c.* 1900 view, members of the Weaver family pose in front of their home at 80 South River Street. Bicycles were used for both transportation and entertainment. (EHS Collection.)

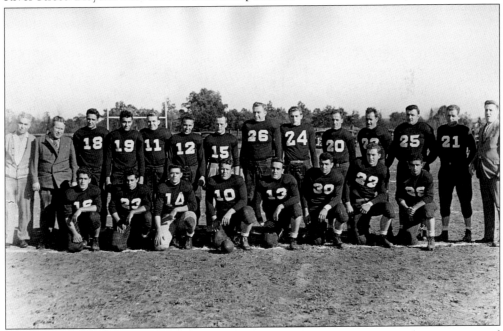

The Greys Club football team was organized in 1924. The 1946 team members are pictured from left to right as follows: (front row) Nick Zaccaro, Joe Cerrato, Fritzi Weller, John Granger, Bob Watton, Kelly Secondo, Ted Curtin, and Paul Mancini; (back row) Joe Morgano, manager Ray Morrison, Ed Ragion, Hank Bregnoli, "Wee" Crowley, "Coco" Gaetani, "Reggie" Charette, Stan Sidoe, "Chevy" Zaccaro, Fred Kotfila, Stan Kotfila, "Norbie" Senio, Frank Mnich, and coach Phil Blaney. (Member Collection.)

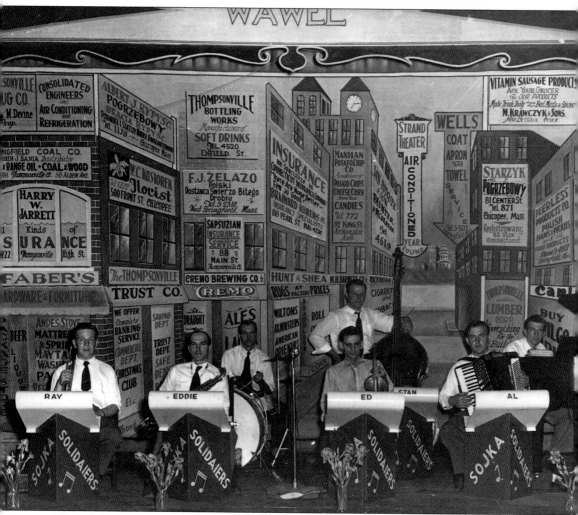

The Polish National Home was dedicated on July 1, 1923. The ceremony was a festive occasion that drew a huge crowd. Organized and built to provide support for the Polish community, the building was financed entirely by the sale of shares at $5 each. Purchasers became voting members of the Polish National Home. The organization recently celebrated its 75th anniversary.

The stage was decorated with advertising from many businesses, some in English, others in Polish. Some of the local companies included the Thompsonville Drug Company, the Thompsonville Bottling Works, Faber's Hardware and Furniture store, the Thompsonville Trust Company, and the Thompsonville Lumber Corporation.

Many events and activities took place at the Polish National Home, including polka bands as a favorite form of entertainment. Al Sojka's Polka Band was nationally known. (Member Collection.)

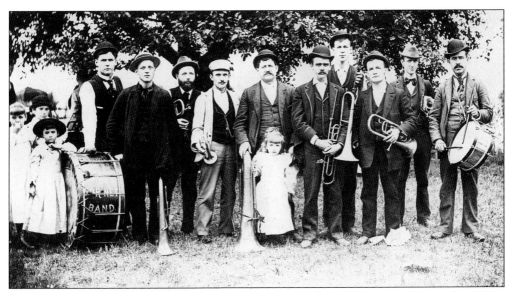

Bands were popular social clubs for boys and men in the late 1800s and well into the 1900s. The Thompsonville Cornet Band was one of the town's many bands and drum corps. Band members are pictured from left to right as follows: E. Bromage, W. Braginton, M Gaybar, M. Sumner, F. Gleisman, J. Jenkins, A. Brown, J. Slamon, F. Glee, and W. Larkin. (Hilditch Photo Collection.)

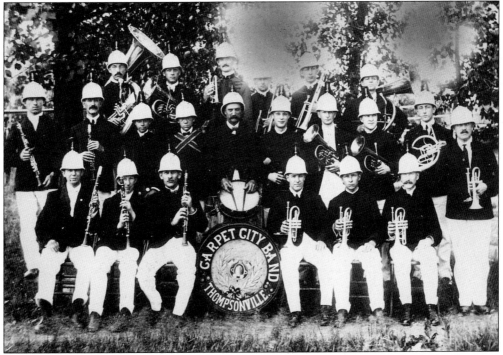

Bands were also a popular form of entertainment in the days before radio and television. Competitions between bands were held regularly, with audience reaction determining the winners. The Carpet City Band was probably Thompsonville's most famous band. Pictured are members dressed in full uniform, posing with their instruments. (EHS Collection.)

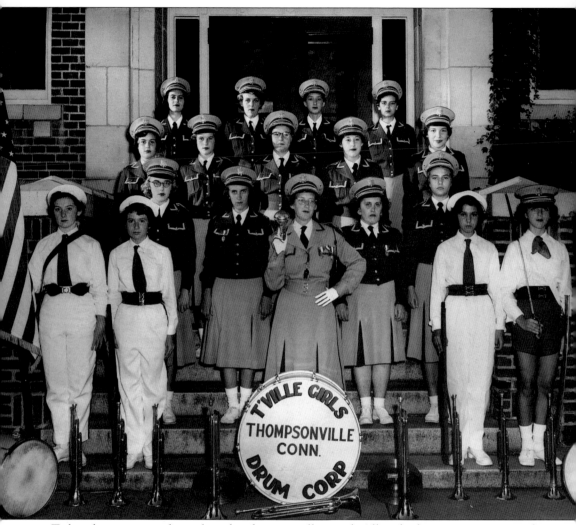

Today, drum corps and marching bands are usually co-ed. All-male drum corps were popular for decades, before corps like the T'ville Girls Drum Corp, photographed in 1952, gave young women a chance to participate. Band members, from left to right, are as follows: (first row) Irene Chernavich, Christine Arre, Joan Fields, Eva Sika, and Mary Buttacavoli; (second row) Barbara Bak, Theresa Andrews, Lorraine Roberts, and Linda Ashton; (third row) Jacqueline Leone, Sally Field, Patricia Frangiamore, Anna Scalia, and Mary Burke; (fourth row) Angelina Buttacavoli, Patricia King, Joyce Grosso, and Celeste Bottone. (Member Collection.)

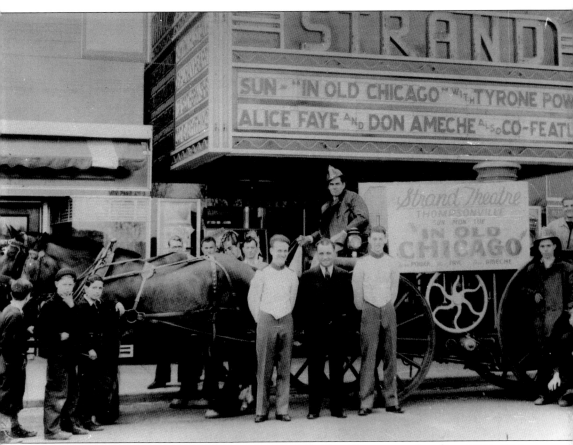

The film, *In Old Chicago*, starring Tyrone Power and Alice Faye, was released in 1938. With a record budget of $2 million, it was Fox's response to MGM's special effects spectacular, *San Francisco*. Theaters across the country heavily promoted the film, and the Strand Theater on Main Street was no exception. The Strand Theater has seen many tough years since then, but it is now being restored by a dedicated group of volunteers. (Member Collection.)

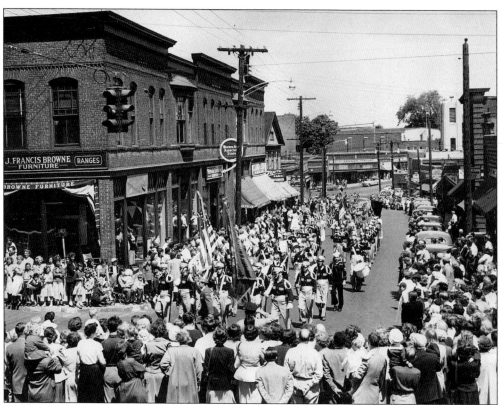

The new Mulligan block was very close to its original condition at the time of this photograph; some of the businesses in the building had changed, but Browne's Store was still in operation at the corner. World War II veterans are seen marching on a paved road, and the trolley tracks are gone, having been torn up in a WPA project during the Great Depression. The Browne Block burned in March 1979. (Member Collection.)

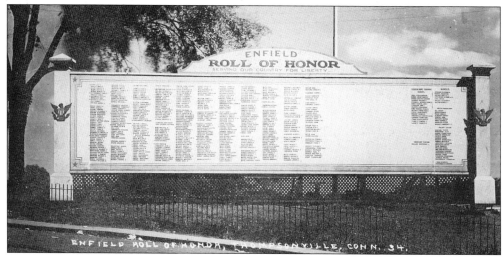

The Enfield Roll of Honor was located beside the dam of Freshwater Pond. The names of the men and women who served during World War II were listed on the board to honor them for their sacrifices. (MAP Collection.)

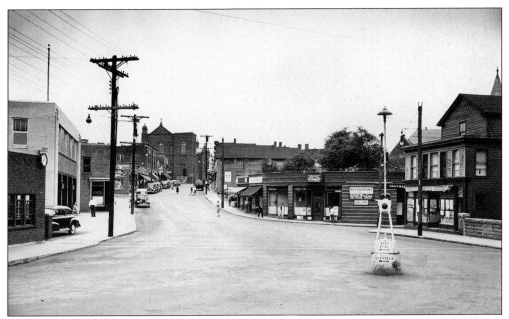

This 1940s view, looking south on Pearl Street, shows the bus station on the left. Thompsonville's present fire station, behind it, was built by the WPA and dedicated in May 1941. The old fire station, behind the new station, along with St. Patrick's Church at the end of the street survive today, but most of the other buildings are gone. (Hilditch Photo Collection.)

This photograph, looking north along North Main Street, was taken at the same time as the one above. The bus station was on the east side of the street, and J.C. Penney, the Strand Theater, and the old high school were on the west side. North Main Street turned east and passed in front of the First Presbyterian Church in the distance. Only the theater building remains today. (Hilditch Photo Collection.)

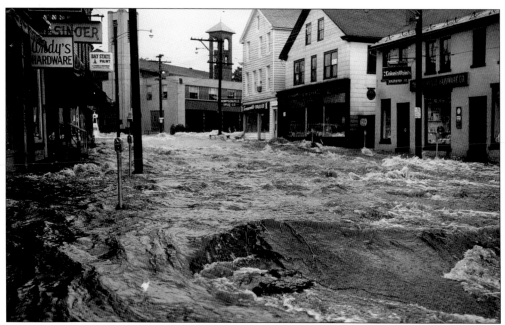

Fourteen inches of rain fell between August 18 and 19, 1955, overwhelming streams and rivers in Enfield. Thompsonville was devastated when Freshwater Brook overflowed its banks and ran in a torrent down Main Street, past the carpet mills and into the Connecticut River. (EHS Collection.)

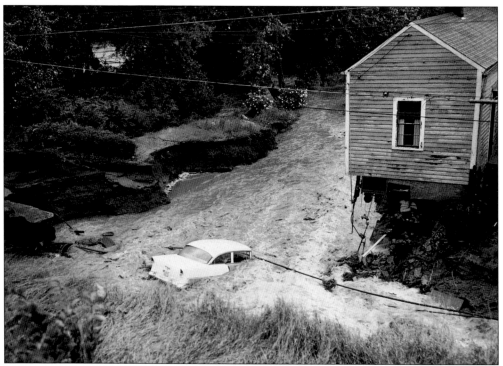

Damage from the 1955 flood was severe, as this photograph, looking east from Asnuntuck Street, clearly shows. (EHS Collection.)

Three

THE CARPET INDUSTRY
ORRIN THOMPSON'S LEGACY

Thompsonville's carpet industry, which at its peak employed thousands of workers, was founded by Orrin Thompson. Born in Suffield, Connecticut, on March 28, 1788, Thompson's first business venture in Enfield was in 1814 as a store owner. Seven years later, in 1821, he joined the New York carpet importing firm of Austin and Andrews. After only two years, he was able to purchase a partnership in the firm, which then became Andrews, Thompson, & Company. Across the Atlantic, the Scottish carpet manufacturers, Gregory, Thomson & Company, were seeing their profits gouged by rising import duties imposed upon their product. By 1828, they were ready to form a partnership with Thompson's company to produce carpet in the United States. Skilled weavers were sent by Thomson & Company from Scotland to Enfield to work in the new mill. Andrews, Orrin Thompson, and James Elnathan Smith invested $35,500 in the project, and the area's carpet industry was born as the Thompsonville Carpet Manufacturing Company.

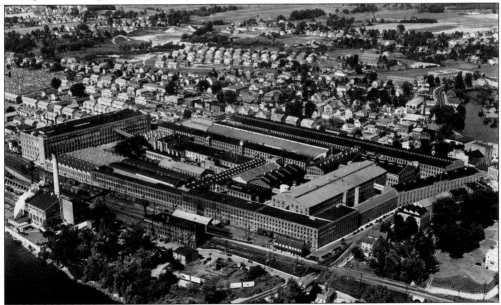

In this 1930s aerial view of the Bigelow-Sanford Carpet Company, notice the long building in the background; this was the 1,000-foot-long tapestry mill. On the left, beside the Connecticut River, is the powerhouse. The complex, which is listed on the National Register of Historic Places, was recently converted to apartments and commercial space in one of the largest historical restorations in the Northeast. Several buildings, including the tapestry mill, were demolished as part of the project. (EHS Collection.)

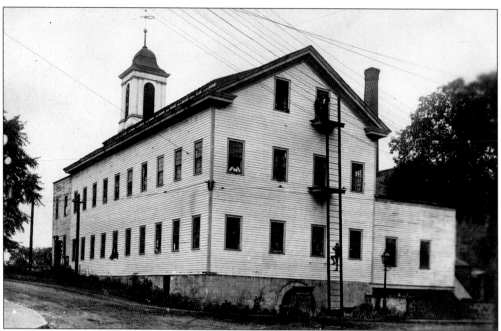

In 1828, Orrin Thompson purchased the waterfall on Freshwater Brook to be the site of his new carpet mill. Construction began immediately on a 14-foot-high, 118-foot-wide dam to provide power for the mill. At the same time, the mill, which was known as the White Mill, was built to straddle the brook. Early in the summer of the next year, the first pieces of carpet were woven. The tailrace from the mill's waterwheel is visible in the photo, as is the bell tower that was used to summon the employees in the days before wristwatches and alarm clocks. The White Mill was torn down in 1900 to make way for realignment of the trolley tracks in order to eliminate a dangerously sharp curve in the tracks as they went around the unused building. (Hilditch Photo Collection.)

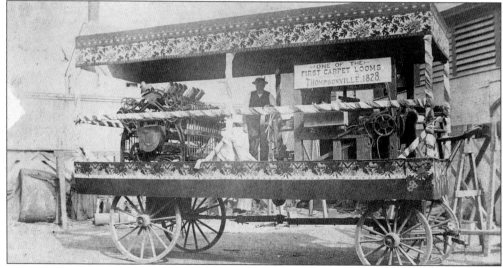

While there are no photographs of the inside of the White Mill during its early years of operation, this photograph shows one of the early looms from the mill when it was exhibited in the late 1800s. (EHS Collection.)

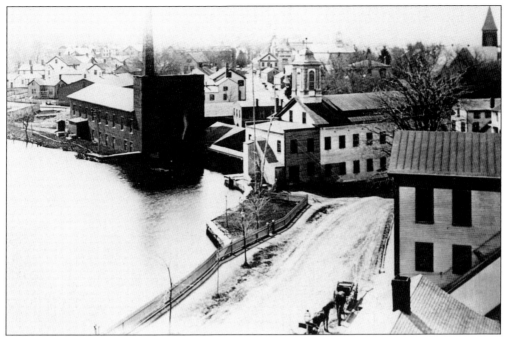

St. Patrick's Church had not been built when this *c.* 1880s photograph of Freshwater Pond and the White Mill was taken. The use of the building to the left of the dam is unknown, but in later years it served as the police station and as a bowling alley. The tower (right) is the Methodist church on High Street. North Main Street is in the foreground. (EHS Collection.)

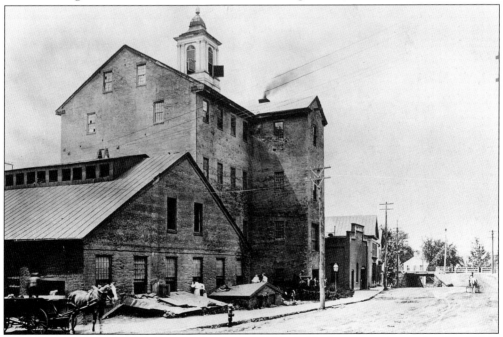

The Dye House, Black Mill, Engine House, and Hilditch block were on the south side of Main Street beside the railroad underpass. Carding, spinning, and weaving operations were housed in the Black Mill, which was completed in 1833. (Hilditch Photo Collection.)

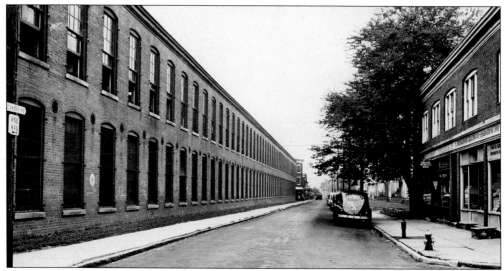

The Thompsonville Carpet Manufacturing Company went bankrupt in 1851. In 1854, investors from Hartford purchased the company and founded the Hartford Carpet Company. In 1901, two banking houses, Kidder Peabody and F.S. Mosely, bought out E.S. Higgins & Company of New York and then merged with the Hartford Carpet Company, forming the Hartford Carpet Corporation. Higgins's equipment was moved to Thompsonville and a major modernization and expansion project was initiated that added 400,000 square feet of factory space. One of the buildings added was the 1,000-foot-long tapestry mill on Pleasant Street. (Hilditch Photo Collection.)

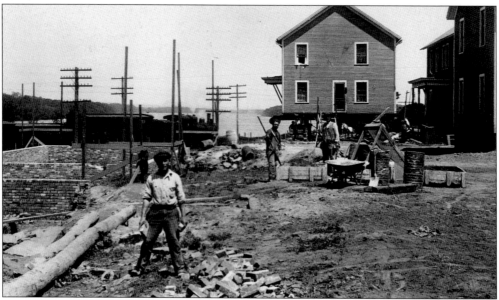

Construction of new carpet mill buildings usually required the removal of existing structures. This house was moved from the Tariff/Whitworth Street area to West Street to make room for a new Axminster Mill in the 1920s. The site had been a baseball field; one story boasts that the longest fly ball ever hit in Thompsonville was hit at this location. According to the tale, the ball landed in an open boxcar in a passing northbound train and had to be retrieved in Springfield. (Member Collection.)

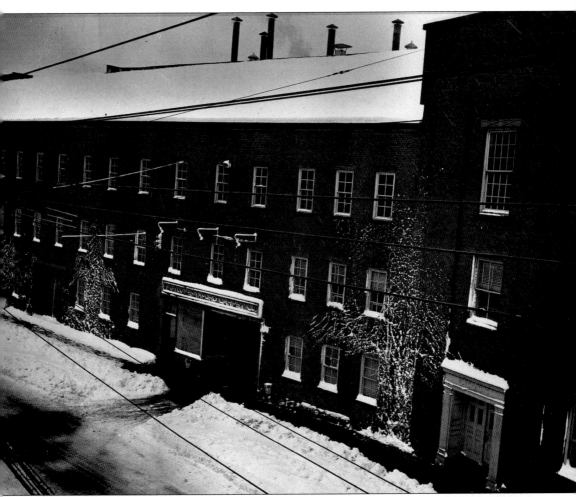

In 1914, the Hartford Carpet Corporation merged with the Bigelow Carpet Company of Clinton, Massachusetts, forming the Bigelow-Hartford Carpet Company. Fifteen years later, in 1929, just one month after the stock market crashed and at the beginning of the Great Depression, the Bigelow-Hartford Carpet Company merged with Stephen Sanford & Sons in Amsterdam, New York, and created the Bigelow-Sanford Carpet Company, Inc. In later decades, Bigelow-Sanford Carpet Company employees passed through the main gate on their way to and from work. Lunch pails were hoisted up to mill windows on ropes at lunch time after being brought fresh from home. (Hilditch Photo Collection.)

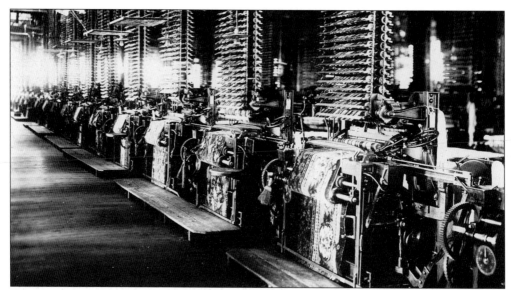

By the early 1900s, there were hundreds of looms in the Thompsonville carpet mills that produced millions of yards of carpet each year. The combinations of colored yarns wound on spools on a series of frames controlled the pattern in the cut-pile carpet woven on Axminster looms. (Hilditch Photo Collection.)

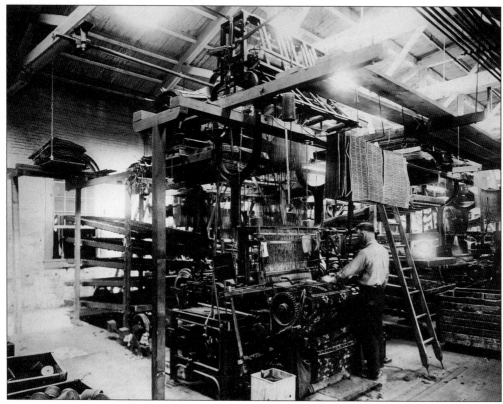

Punched paper cards, visible above the weaver, controlled the pattern woven into the carpet by Jacquard looms. (EHS Collection.)

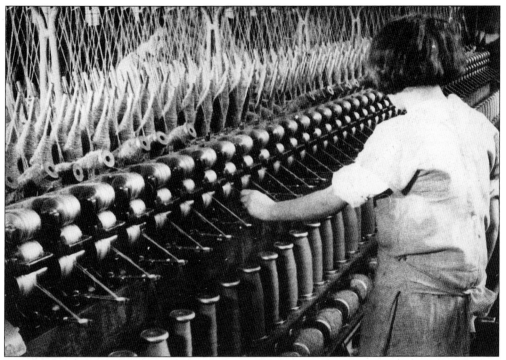

Carpets manufactured in Thompsonville started as raw wool, which was spun into yarn and dyed at the mills. (EHS Collection.)

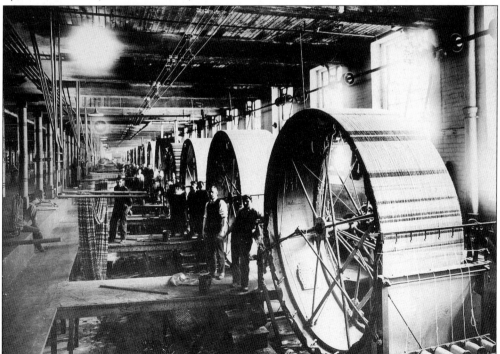

Not all patterns were woven into the fabric. Printed tapestries were produced in the Drum Print department. Each drum applied part of the pattern. (EHS Collection.)

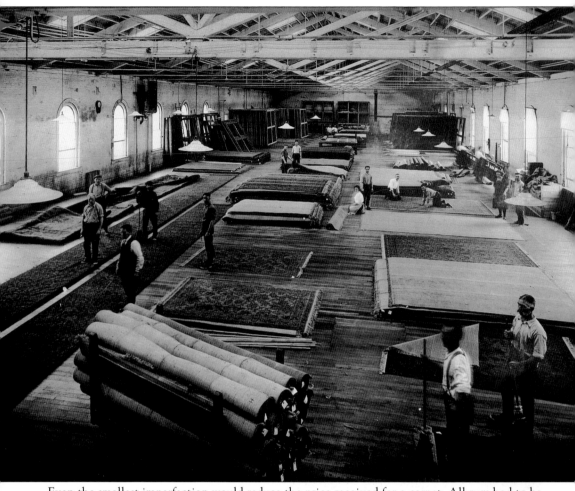

Even the smallest imperfection would reduce the price received for a carpet. All rugs had to be carefully inspected and any imperfections fixed before leaving the mill. (EHS Collection.)

When steam power and later, electricity, became available, the carpet mills at Thompsonville were no longer limited by the capacity of Freshwater Brook to power them. The Hartford Carpet Company built a 4,000-horsepower, coal-fired power plant on North River Street between the mills and the Connecticut River to meet the needs of its rapidly growing operations. Today, only the smokestack remains. (MAP Collection.)

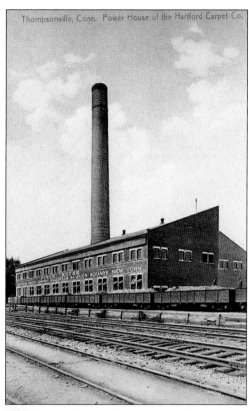

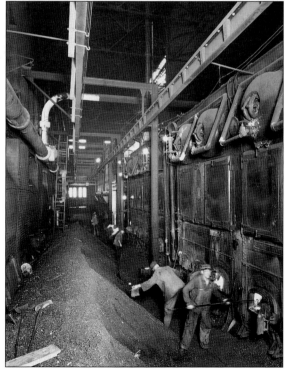

Working in the powerhouse was a hot, dirty, and dangerous job, as this photo clearly shows. (EHS Collection.)

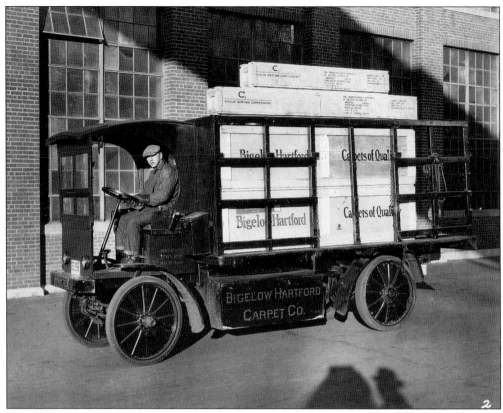

In addition to standard "off the shelf" patterns, the carpet companies in Thompsonville produced many unique patterns for businesses and other special circumstances. This load of carpet was bound for the American Exposition in Seville, Spain, c. 1929. Note the shadow cast by the photographer and his camera.

During the 1920s, the United States experienced a boom in luxury hotel construction. The Bigelow-Hartford Carpet Company profited from this boom, designing and weaving custom carpeting for hotels, including the Hotel Statler in Buffalo, New York, the Commodore Hotel in New York City, and the Biltmore in Los Angeles.

The mills also produced special carpet patterns for major retailers. Some, like Saks Fifth Avenue in New York, wanted specially designed carpeting for the floors of their stores. Others demanded unique patterns that would only be sold through their stores.

Carpets produced in Thompsonville were not limited to use in buildings. The Pullman Company purchased carpets for use in their luxury and passenger railroad cars. Bigelow-Hartford produced carpet for the steamship *Leviathan*. And, perhaps most unusually, custom-designed carpeting was woven in Thompsonville for use in the Argentine battleship *Rivadavia*! (EHS Collection.)

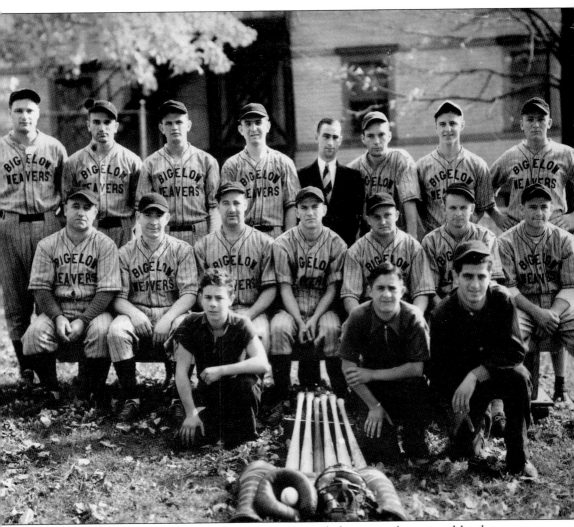

There were many sports teams in Thompsonville, including several sponsored by the carpet companies. The Bigelow Weavers baseball team was one of them. Team members, from left to right, are as follows: (first row) unidentified, "Rabbit" Sorroco, and Harry Mangerian; (second row) Dick Copeland, Dutch Choteau, Teo Patrivita, Joe Labutis, Eddie Gongola, Benny Jakubiec, and "Lefty" Jedziniak; (third row) Bucky Angelica, "Si" Silanski, Ed Kukulka, Wally Legienza, Mac Gray, Eddie Naughton, Eddie Pohorylo, and Ed Mendrala. (EHS Collection.)

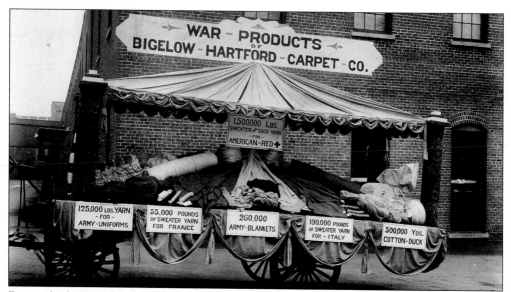

During both WW I and WW II, the Thompsonville carpet mills were converted to produce materials needed for the war effort. This parade float proudly recounts the mills' contributions to efforts in WW I. Production for WW II was much higher. (EHS Collection.)

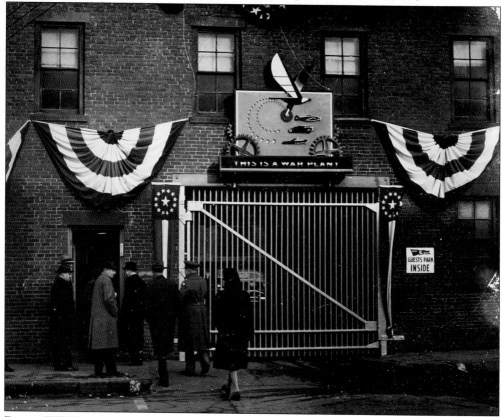

During WW II, much of the production at the Bigelow-Sanford Carpet Company was switched to war materials, and the mill was designated a war plant. (EHS Collection.)

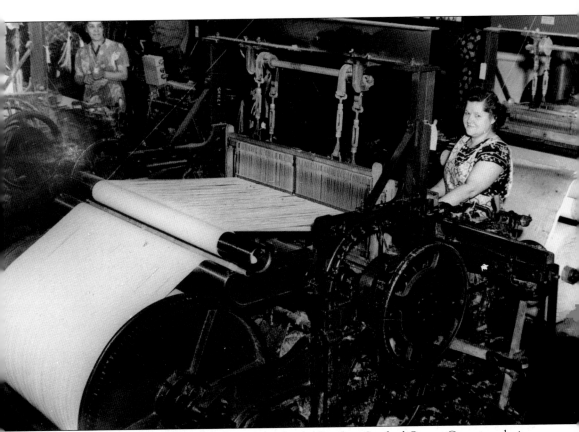

Many materials were produced for the military by the Bigelow-Sanford Carpet Company during WW II, including 19,773,666 yards of cotton duck, which is being woven in this photograph.

A total of $154,152,432 in materials was produced at the Bigelow-Sanford plant in Thompsonville between 1942 and 1945. War materials accounted for $86,274,515—or 56 percent—of that production. During the peak production years of 1943 and 1944, war materials accounted for about 70 percent of the plant's production. Not surprisingly, for a mill equipped to weave carpeting, the war materials included 19,773,666 yards of duck (canvas-like material), 6,020,779 blankets, another 6,011,112 yards of blanket cloth, and more than $6,000,000 worth of parachutes, cot covers, seat covers, turret covers, generator covers, berth bottoms, squad tents, crew bags, desk hoods, and camouflage netting. Production was not limited to cloth, however, and the plant's machine shops turned out over $7,000,000 worth of machines and parts ranging from bullet loaders to radar parts. As a result, the plant earned four Army-Navy E awards for excellence, the first on January 5, 1944, and the others on June 24, 1944, January 13, 1945, and July 28, 1945. (Member Collection.)

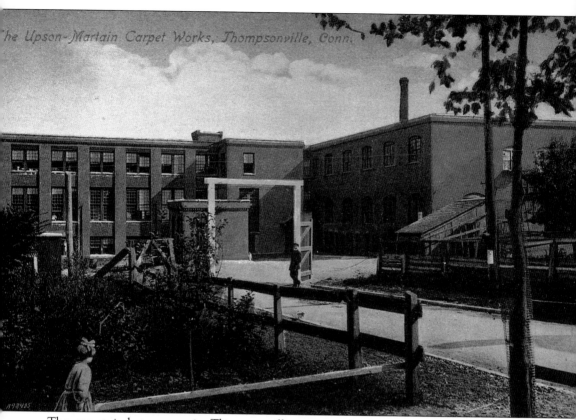

The carpet industry story in Thompsonville is primarily the story of the Thompsonville Carpet Manufacturing Company and the many companies that evolved from it through buyouts and mergers. The story is not complete, however, without mentioning the one major attempt at competition in Thompsonville. In 1902, Lyman A. Upson, a former assistant to the superintendent of the Hartford Carpet Company, along with Henry G.T. Martin of New York, built a carpet mill at the east end of Central Street. By 1911, they had 50 axminster looms turning out carpet. Many of their looms had been made by the G.H. Bushnell Press Company in Thompsonville. Upson-Martin could not compete with the giant Hartford Carpet Corporation, and the building was sold to Hinsdale-Smith for use as a tobacco warehouse. Later occupants of the building included National Print and Hallmark Cards' first factory in Enfield. The building was demolished during Thompsonville's 1970s urban renewal project. (MAP Collection.)

Four

SCITICO & HAZARDVILLE

THE EASTERN VILLAGES

Named for Chief Scitico of the Scantic Indians, Scitico is the eastern most section of Enfield that did not split to become Somers in 1734. Settlement of the area did not begin until c. 1713. In 1714, Nathanial Gray built a grain mill at Scitico, and Israel Meacham built works to smelt bog iron at Powder Hollow. In 1835, Loomis, Denslow, & Company built the first gunpowder mill in Powder Hollow. By the mid-1840s, the gunpowder industry in the hollow had grown considerably and was acquired by Col. Augustus Hazard. Hazard's business not only provided work for the people living in the village nearby, but also for important public buildings, including St. Mary's Episcopal Church and the Hazardville Institute. There are various stories concerning when and where the vote was taken, but at some time around 1850, the village was named Hazardville in honor of the man who contributed so much to its prosperity. Powder Hollow got its name from his industry as well.

Unlike Thompsonville, most of Hazardville's early buildings survive to this day. In this c. 1925 photograph, looking east on Hazardville's Main Street, are the following businesses: the Hazardville Institute (first building on the left), a meat market, and George Campbell's barbershop. The Hazardville Hotel is the first building on the right, and the Methodist Episcopal Church and Parsonage are located behind the hotel. Main Street is now called Hazard Avenue, Route 190. (Hilditch Photo Collection.)

The Hazardville Institute was completed in 1869. The Institute provided many services to the people of Hazardville over the years. At various times, it housed a meeting hall, library, community theater, basketball court, and Grange Hall. Voting, Sunday school classes, dance classes, Halloween parties, and graduation exercises were held at the Institute. The building is vacant today, and attempts to restore it have been unsuccessful. (Hilditch Photo Collection.)

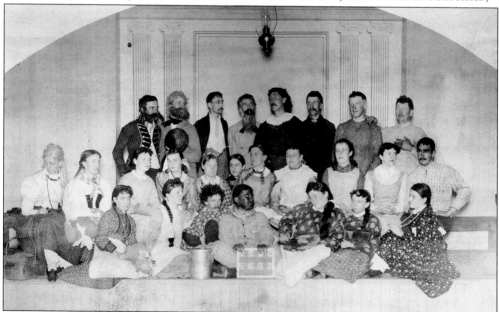

Minstrel shows were common events from the 1840s to the mid-1900s. The people of Hazardville regularly staged these comic variety shows for the entertainment of their fellow villagers. One of the defining characteristics of a minstrel show was the performance in black face by one or more of the troupe. In keeping with the comic nature of the show, careful examination of the photograph will reveal that some of the "women" and "children" in the troupe sport substantial mustaches. (MAP Collection.)

The Hazardville Hotel was built in Scitico in 1853 by Sylvester Charter and opened in 1854. One story has it that Hazardville got its name during a banquet at the hotel when a Hazard Powder Company foreman named William Colvin suggested naming the village at the west end of Scitico for his employer. This 1912 photograph shows Sylvester Charter standing in front of the hotel on his 87th birthday. (Donna Charter Luce Gottier Collection.)

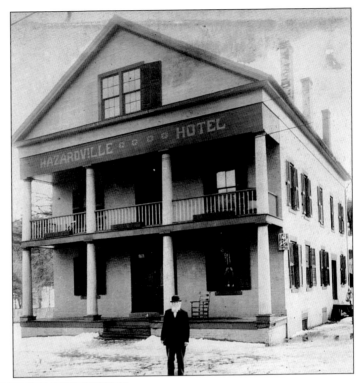

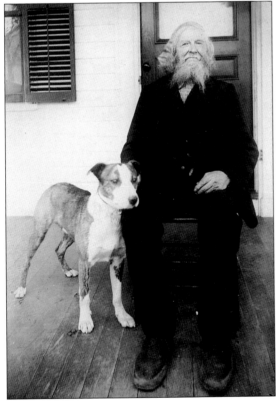

In 1912, Sylvester Charter, builder of the Hazardville Hotel, posed with his dog John for this photograph on the porch of the hotel. (James Luce Collection.)

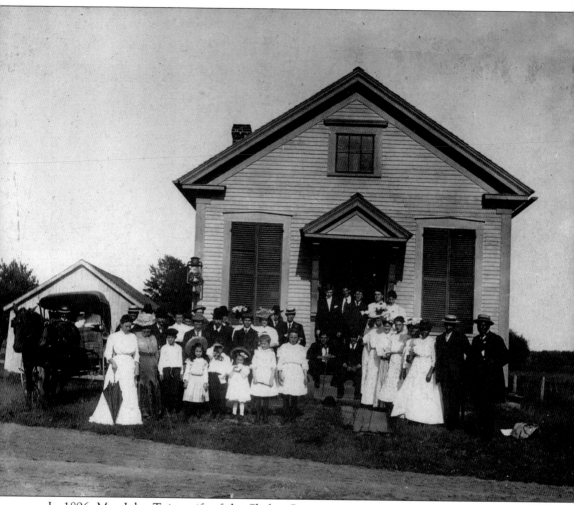

In 1896, Mrs. John Twiss, wife of the Shaker Station postmaster, organized the girls from the Jabbock district of Enfield to form a social club called the Mrs. Twiss Circle of Busy Bees. For the next few years, the group met at various people's homes to socialize while Mrs. Twiss taught them to sew. In 1901, Mrs. Twiss built the Busy Bee Hall on the land owned by H. Kenny King at the intersection of North Maple Street and Shaker Road.

Many activities took place at the hall. Sunday school classes and worship services were held every Sunday. The Busy Bees were known for the fine May breakfasts and winter suppers they served at the hall; people came from as far away as Springfield to attend them.

The Busy Bees incorporated on July 1, 1916, following Mrs. Twiss's death. Twenty-one years later, the group disbanded and the land on which the hall was built reverted to the King estate. The hall itself was purchased by Frank Olmstead, who moved it across the road to the northeast corner of the intersection and converted it into a home, which it remains today. In keeping with Mrs. Twiss's love for children, the proceeds from the sale of the home went to benefit the Newington Home for Crippled Children. (Member Collection.)

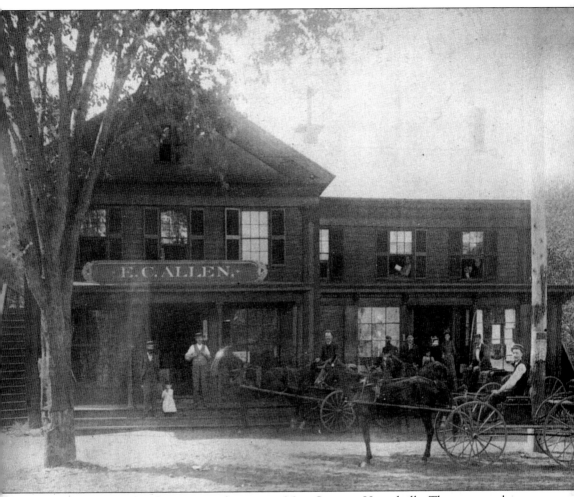

In 1869, John Bridge and Sons opened a store on Main Street in Hazardville. The store was later called Bridge Brothers. E.C. Allen and A.W. Gowdy bought the store in 1881. One year later, Allen bought out Mr. Gowdy's interest. The store was destroyed by fire in January 1919. The firm occupied quarters in a building across the street until a new brick building was completed on the site of the original store.

In 1911, E.C. Allen's store was listed as the largest general store between Hartford and Springfield. In 1992, the store celebrated 100 years in business. The family decided to close the business shortly afterward, but the building continues to house retail businesses. (Ed Allen Collection.)

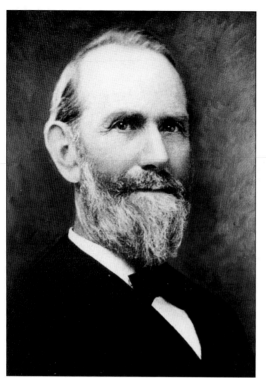

Amos D. Bridge was born in Milton, Kent, England, and arrived in Scitico in April 1842 at the age of four. His father had come to work at the gunpowder mills. Amos and his brothers also went to work at the mills. Shortly after the Civil War, Amos Bridge, Edward Pricket, and David, George, and Andrew Gordon started the Hazardville Bonnet Company on Oak Street. They also manufactured the wooden boxes in which the bonnets were shipped. At about the same time, Amos built a large dairy farm that operated until c. 1940. Amos Bridge worked at both the powder mills and the bonnet company until 1875, when he left the Hazard Powder Company to work full time at his own businesses. Bonnets were no longer fashionable, so he closed down the bonnet operation, built a sawmill, and greatly expanded the production of wooden boxes. As a contractor, he built roads, supplied railroad ties for the trolley lines in and around Enfield, and built houses and other buildings. (EHS Collection.)

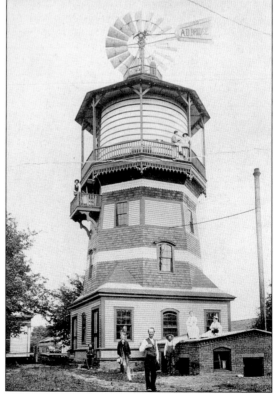

In 1892, Amos D. Bridge designed and built this elaborately decorated windmill and water tower for Hazardville's public water supply. In 1899, he chartered the Hazardville Water Company, which still operates today but is no longer owned by the Bridge family. (EHS Collection.)

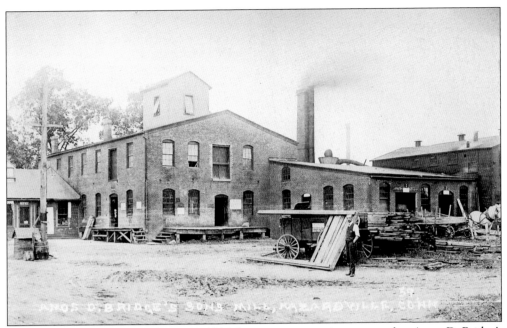

After Amos D. Bridge passed away in 1906, his company was incorporated as Amos D. Bridge's Sons, Inc. by his sons, Stephen, Allyn, William, Homer, and Charles, and his nephew, David Bridge. (Member Collection.)

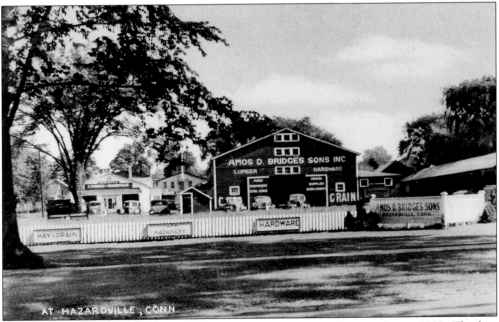

Amos D. Bridge's Sons, Inc. continued to expand, adding appliance sales in 1928. The box division also started producing cable reels that year. Their lumberyard on Main Street (Hazard Avenue), shown in this 1940s postcard, operated for decades before being sold to a local chain of lumberyards. Cable reels are still manufactured at their factory in Hazardville but under different ownership. (MAP Collection.)

Fairlawn Avenue was named for the home and estate of Edward Pricket, superintendent of the Hazard Powder Company from 1867 to 1905. It was also known as School Street, the name it retains today, because the Hazardville Grammar School was at its intersection with Main Street (Hazard Avenue). Both names appear on postcards from the early 1900s. Despite the name's popularity, however, Fairlawn Avenue was never the legally recognized name of the street. (MAP Collection.)

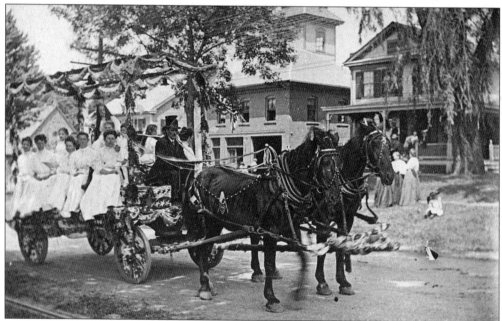

This patriotically decorated float passed in front of the old Hazardville Fire Department in the early 1900s. The old Hazardville fire station was built in 1898 at the cost of $300 for the land and $1,400 for construction of the building. It was torn down in 1957 after the current station was built behind it. (MAP Collection.)

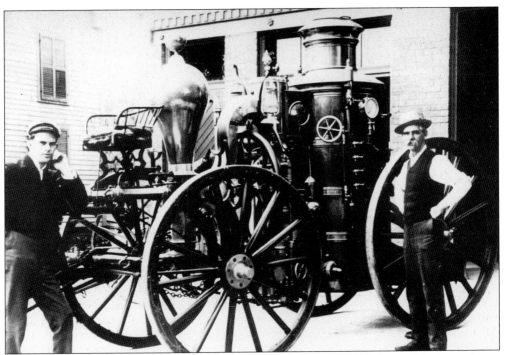

Hazardville's steam pumper wagon was a source of pride for the village's residents. (Member Collection.)

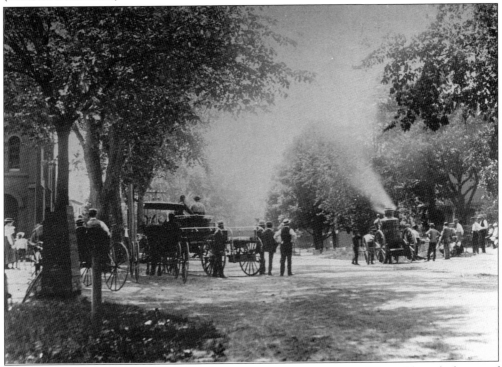

The Hazardville Fire Department tested its new steam pumper to see if it could reach the top of the steeple at the Methodist church. (EHS Collection.)

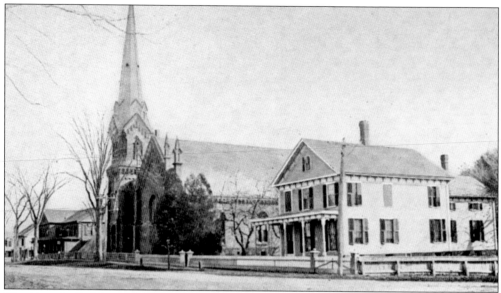

The Hazardville United Methodist Church was founded in 1835. Having outgrown their first church building, the congregation built a new church in 1872, which is still in use today. (Member Collection.)

St. Bernard's Roman Catholic Church was founded c. 1863. After meeting for many years in Hazardville's old wooden schoolhouse, the congregation completed their first brick church in 1880. This building was used for 75 years before it was torn down in 1955 to make room for construction of a new modern church. The rectory at left, which dates to 1800 and is the oldest house in Hazardville, still survives today. It was originally owned by Daniel Gowdy, who operated a gin mill in Scitico, and was later owned by Sylvester Charter, the builder of the Hazardville Hotel. (MAP Collection.)

During the 1850s, the growing community of English gunpowder makers in Hazardville was without a church of its own. Other churches in Enfield did not meet the community member's religious needs. Col. Augustus Hazard donated land in Hazardville for them to build a church on. The cornerstone for St. Mary's Episcopal Church was laid in 1863. Continuing support for the church was provided by Hazard, who established a $5,000 trust for maintenance of the building. It is still in use today. Hazard Powder Company mill superintendent Pricket's house, Fairlawn, is visible in the distance. (Member Collection.)

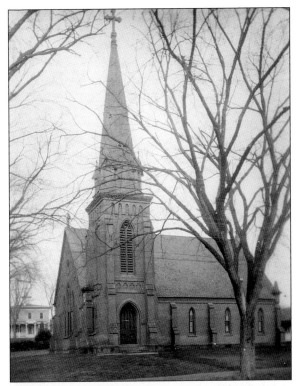

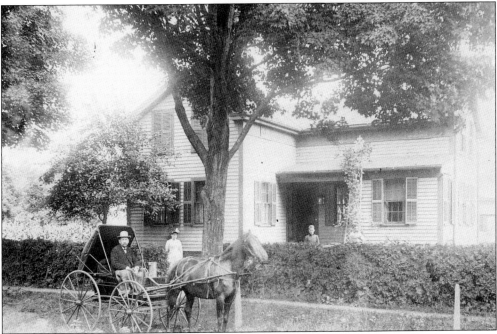

While churches took care of the spiritual well-being of the people of Hazardville, doctors were needed to take care of their physical well-being. Dr. Adams's house, shown here in 1891, still stands on the corner of Hazard Avenue and Cedar Street. The man in the carriage was probably Dr. Adams. (Member Collection.)

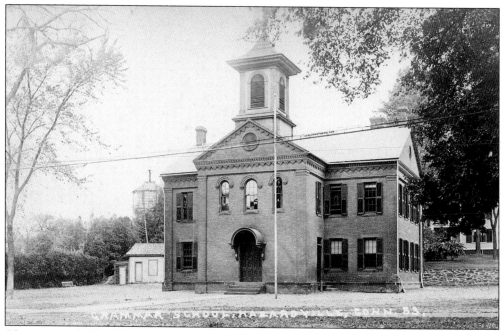

Classes were held at the Hazardville Grammar School beginning in 1863. All grades were taught there until 1904, when high school classes were discontinued. The school did not have indoor toilets or central heat until 1918. A large addition was completed on the Hazard Avenue end of the building in 1925. The building still stands on the corner of School Street and Hazard Avenue, but it is no longer used as a school. (Member Collection.)

In this 1930s snapshot, students pose for the camera in one of the classrooms in the Hazardville Grammar School. (EHS Collection.)

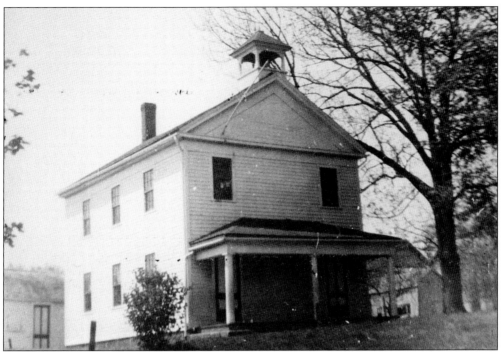

The Scitico School District was established in 1730. The Scitico School was built in 1854 with funds raised by women from the community. At first, classes were held on the lower floor and religious services on the upper floor. Later, grades 1-3 were taught on the first floor and grades 4-6 on the second floor. After serving as a school, the building became the Enfield Grange Hall. The bell from the tower was moved to the Hazardville Memorial School when it opened. (Arthur Maynard Collection.)

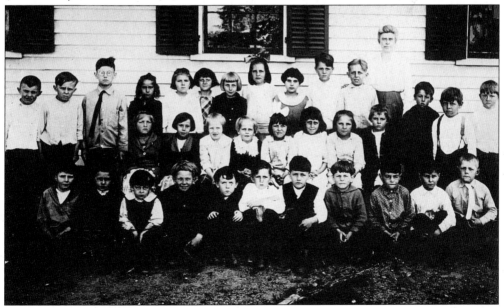

Teacher Jennie Whiting stands with her class outside the Scitico School. (Arthur Maynard Collection.)

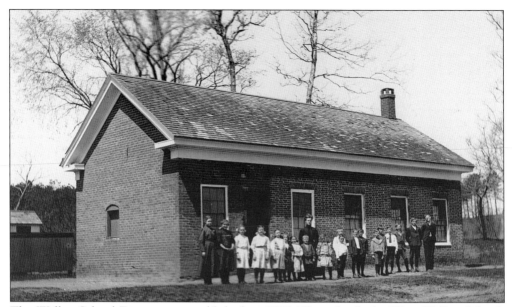

The Wallop School District was established in 1735. This school, the West Wallop School, located on the corner of Wallop School Road and Abbe Road, was built in 1800 to replace an earlier wooden school that had burned down. Clara Beasley was the teacher when this photograph was taken in 1909. Classes were held at the school until 1947. It is currently a museum operated by the Enfield Historical Society, Inc. (WS Collection.)

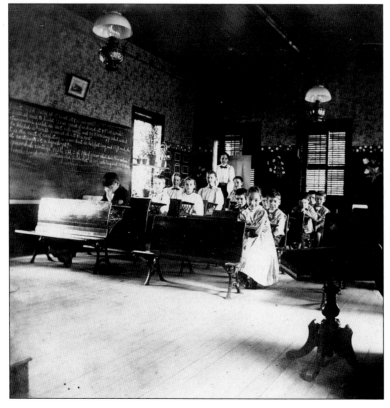

Nellie M. Jones was the teacher when this photograph of the interior of the Wallop School was taken c. 1900. (EHS Collection.)

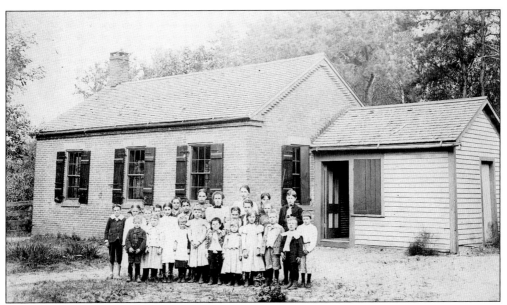

The Jabbock School District, located north of Hazardville and west of Shakers School District, was founded in 1775. (Member Collection.)

Enfield's newest high school, Enrico Fermi High School, is located on the corner of North Maple Street and Moody Road in Hazardville. A century ago, Hazardville's high school students attended the Hazardville Grammar School and the future site of Fermi High was still a farmer's field. Moody Road can be seen in the background in this photograph. (Member Collection.)

Summer Avenue in Scitico is now called Leary Road. The house in the foreground was the Leary Homestead. (MAP Collection.)

Thomes's Market (left) was located on Route 190, east of the railroad tracks in Scitico. (MAP Collection.)

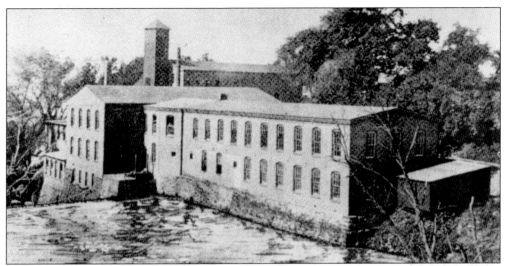

In 1901, the Gordon Brothers built a brick mill on the Scantic River in Scitico, where they operated what would today be classified as a recycling business. Rags and cloth scraps were processed at the mill to extract their wool content. The scraps were treated with acid to destroy any cotton content, and the wool was carded. The result was a very good grade of wool that could be sold back at profit to the same mills from which the scrap was purchased. The Gordon Brothers also owned most of the nearby housing and charged their employees between $1.40 and $2.50 per week for rent. They showed unusual concern for their employees' well-being and actually waived the rent for days when the employees were unable to work due to illness. (EHS Collection.)

Water power was one of the natural resources that attracted settlers to Hazardville and Scitico. Pine Point Lake in Hazardville was made by the Enfield Shakers to supply water for a sawmill. The Pine Point name came from the 150 acres of pine trees planted there by a Shaker named Omar Pease. Most of the trees were lost in the 1938 hurricane. After the Shakers left Enfield, the lake became a popular recreation area. (MAP Collection.)

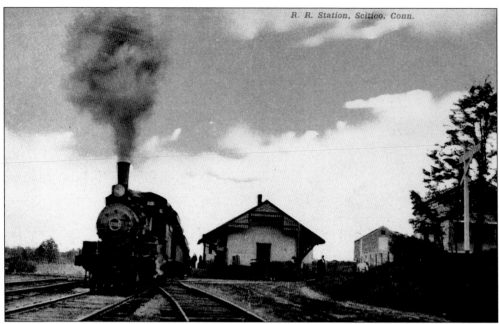

In 1876, the Connecticut Central Railroad, which ran from East Hartford to Springfield, reached Scitico. Despite its location in Scitico, the station was usually identified as Hazardville in railroad timetables, and a "Hazardville" sign was hanging on the station when it was destroyed by fire. The railroad provided passenger and freight service and accepted gunpowder for shipment from the Hazard Powder Company. Some reports indicate that as much as 19 tons of black powder were shipped from Scitico Station in a single day. Prior to the railroad's arrival, black powder had to be shipped by wagon or by flat boat down the Connecticut River to Hartford. (MAP Collection.)

Trolley Conductor Orvillo Prior and Motorman Allen Chilson posed for the camera in their uniforms during the heyday of trolley service in Enfield. Hartford and Springfield Street Railway trolleys began running between Thompsonville and Hazardville on August 23, 1902. Service ended when the company went bankrupt in 1926. The rails were torn up and paved over by the end of 1928. (EHS Collection.)

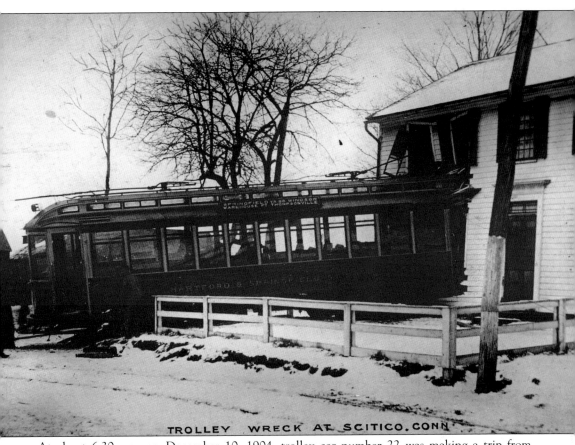

TROLLEY WRECK AT SCITICO. CONN.

At about 6:30 a.m. on December 10, 1904, trolley car number 22 was making a trip from Thompsonville to Somersville when it failed to negotiate the curve at the bottom of the hill between Hazardville and Scitico. The motorman was unable to slow the trolley due to icy rails but remained at the controls blowing the horn to warn people in his path. The trolley jumped the tracks, went up a 3-foot embankment, through a fence, across the lawn, and crashed into the parlor of a tenement house owned by the Gordon Brothers mill. Two children were sleeping in the rooms above the parlor but were uninjured in the crash, despite the fact that the trolley pole came to a stop only inches from one of their heads. One popular story has it that one of the tenants, David Minihan, went outside and invited the motorman and conductor into the kitchen for breakfast, "seeing as they had already found the parlor." The curve in the road has since been straightened, and the house was torn down in the 1970s. (MAP Collection.)

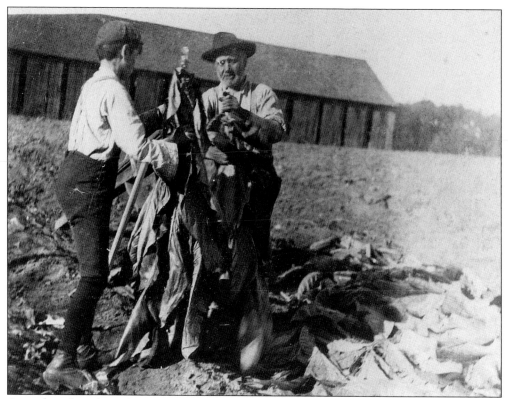

Agriculture has always been very important to Enfield, with tobacco being the most successful cash crop. Connecticut Valley tobacco has long been considered by many to be the best tobacco for wrapping cigars. The recent resurgence in popularity of cigars has resulted in a tobacco-growing boom in Hazardville and Scitico. (EHS Collection.)

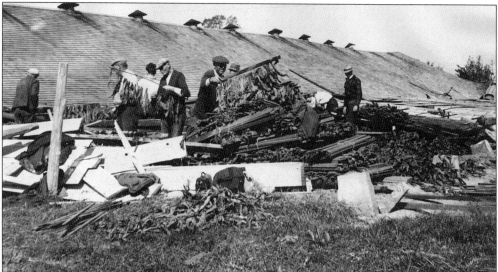

High winds during the hurricane of 1938 damaged or destroyed many tobacco barns in Enfield. The men in this photograph are attempting to salvage the tobacco crop that was drying in a Haas Plantation barn when the hurricane struck. (EHS Collection.)

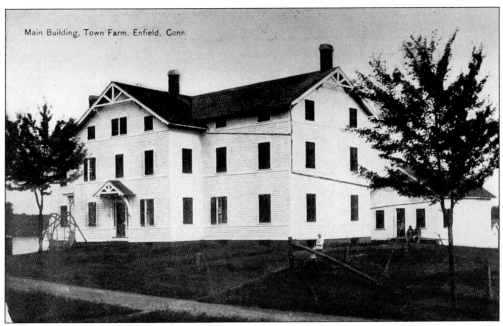

The Town Farm provided room and board for Enfield's poor. Residents had to earn their keep by working on the farm, which was run by Robert and Helen Steele. (MAP Collection.)

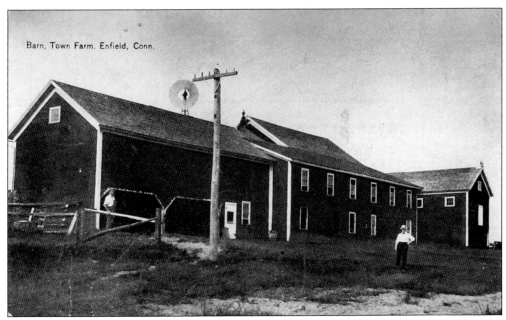

The Town Farm was eventually converted into a fine home and farm by George Poole, who owned a large dairy on Elm Street that was operated by his son-in-law, George Rutherford. (MAP Collection.)

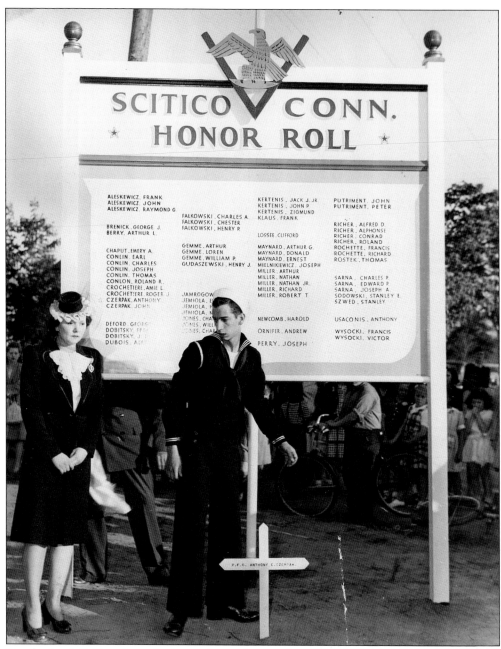

SCITICO CONN.
HONOR ROLL

ALESKEWICZ, FRANK
ALESKEWICZ, JOHN
ALESKEWICZ, RAYMOND G

BRENICK, GEORGE J.
BERRY, ARTHUR L.

CHAPUT, EMERY A.
CONLIN, EARL
CONLIN, CHARLES
CONLIN, JOSEPH
CONLIN, THOMAS
CONLON, ROLAND R.
CROCHETIERE, AMIE L
CROCHETIERE, ROGER J
CZERPAK, ANTHONY
CZERPAK, JOHN

DEFORD, GEORGE
DOBITSKY, FRANK
DOBITSKY, J. J
DUBOIS, ALF

FALKOWSKI, CHARLES A.
FALKOWSKI, CHESTER
FALKOWSKI, HENRY P.

GEMME, ARTHUR
GEMME, LOREN
GEMME, WILLIAM P.
GUDASZEWSKI, HENRY J.

JAMROGOW
JEMIOLA, E
JEMIOLA,
JEMIOLA, N
JONES, CHA
JONES, WILL
JONES, CHAS

KERTENIS, JACK J. JR
KERTENIS, JOHN P
KERTENIS, ZIGMUND
KLAUS, FRANK

LOSSEE, CLIFFORD

MAYNARD, ARTHUR G.
MAYNARD, DONALD
MAYNARD, ERNEST
MIELNIKIEWICZ, JOSEPH
MILLER, ARTHUR
MILLER, NATHAN
MILLER, NATHAN JR.
MILLER, RICHARD
MILLER, ROBERT T.

NEWCOMB, HAROLD

ORNIFER, ANDREW

PERRY, JOSEPH

PUTRIMENT, JOHN
PUTRIMENT, PETER

RICHER, ALFRED D.
RICHER, ALPHONSE
RICHER, CONRAD
RICHER, ROLAND
ROCHETTE, FRANCIS
ROCHETTE, RICHARD
ROSTEK, THOMAS

SARNA, CHARLES P
SARNA, EDWARD P
SARNA, JOSEPH A
SODOWSKI, STANLEY E
SZWED, STANLEY

USACONIS, ANTHONY

WYSOCKI, FRANCIS
WYSOCKI, VICTOR

P.F.C. ANTHONY C. CZERPAK

On the battlefield and on the home front, the people of Enfield have answered the call in every war. Honor Roll memorials were erected during WW II in Thompsonville, Hazardville, and Scitico, listing the men and women who served from each village. The ceremony pictured honors Scitico's Anthony Czerpak, who sacrificed his life for his country. His widow made a different sacrifice. The sailor is Arthur Maynard. Of the three memorials, only Scitico's survives, recently replaced with a new, more permanent monument. The memorial has been maintained since WW II by the Maynard family. (Arthur Maynard Collection.)

Five

THE GUNPOWDER INDUSTRY
COLONEL AUGUSTUS HAZARD'S LEGACY

In 1835, Allen Loomis of Suffield purchased 500 acres of land in Powder Hollow. He formed a partnership with his brothers, Neeland and Parkes, and with a New Haven man named Allen Denslow. Incorporated in 1836 as Loomis, Denslow, and Company, they built the first gunpowder mill in Powder Hollow. Col. Augustus Hazard, a successful merchandising agent from New York, acquired one-quarter interest in the firm in 1837. Over the next six years, Hazard gradually increased his holdings in the company. In 1843, Hazard became the principal owner, and the Hazard Powder Company was incorporated. The company and Colonel Hazard prospered greatly during the 32 years of his leadership. By the outbreak of the Civil War, the Hazard Powder Company was making over $1,000,000 annually, and the mill complex included more than 125 buildings and miles of canals spread over an area 1/2 mile by 1 1/2 miles.

The Hazard Powder Company advertised its products in many ways, including this beautifully lithographed envelope from c. 1900. Highly detailed lithography also appeared on tin signs and posters and on labels on Hazard's powder kegs and canisters. Hazard products included Kentucky Rifle Powder, Indian Rifle Powder, Duck Shooting Powder, Hazard's Electric Powder, Mining Powder, Cannon Powder, and more. Hazard's Smokeless Powder, advertised on this envelope, was not black powder and was not manufactured in Hazardville. It was produced by du Pont and sold with the Hazard label. (Member Collection.)

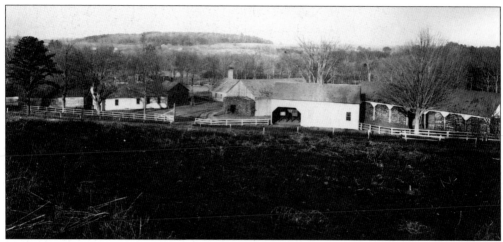

Black powder manufactured by the Hazard Powder Company was widely recognized for its quality. Charcoal, one of the three ingredients in black powder, was often cited as one reason for that quality. Hazard made its charcoal from alder wood gathered in Enfield and surrounding towns. The wood was often gathered by farmers during idle winter months to earn extra cash. The alder was dried in sheds, like the one seen on the right in this photograph, before being burned to make charcoal. (EHS Collection.)

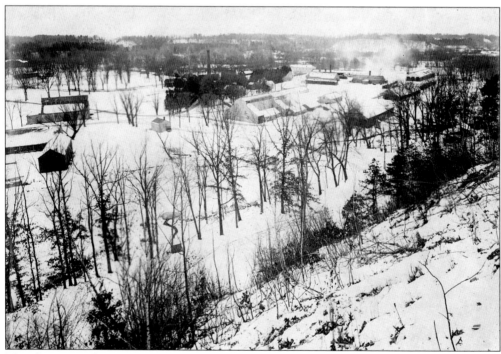

The three ingredients in black powder are saltpeter, charcoal, and sulfur. In the early years, Hazard imported saltpeter from Calcutta, but this source became unreliable during the Civil War because of diplomatic issues with England. In 1864, a saltpeter refinery was built by Hazard to refine nitrate of soda imported from Chile. The refinery is the large building at the center of this photograph. (EHS Collection.)

To reduce the effects of explosions, each step in the black powder manufacturing process was housed in a separate building, often with more than one building set up to perform the same process. Should an explosion occur, it would be possible to continue operations until the damaged building was rebuilt. At least 125 buildings were part of the Hazard Powder Company's operations in Powder Hollow during the Civil War. Approximately 50 buildings were directly involved in manufacturing the gunpowder, and the rest housed supporting operations such as making barrels, kegs, and tins. The exact use of this building is unknown, but the worker on the porch is Alfred Blunden. Workers went barefoot or wore shoes made with wooden pegs or copper nails to prevent sparks. Note the all-wooden shovel, another spark-prevention measure. (EHS Collection.)

The upper double wheel-mixing mill was located north of Cooper Street at the Scantic River. Two sets of 8-ton iron wheels crushed and mixed the black powder ingredients in this mill. The mix had to be kept wet during the process, or the results would be fatal. On September 13, 1858, John Garesche, William Colvin, Stephen Pace, and Thomas Ball were killed when 1,800 pounds of powder exploded while they were experimenting with a dry grinding process. (EHS Collection.)

In 1842, a second dam called the "upper" dam, was built on the Scantic River to divert water into a canal for a wheel mill that was later nicknamed the "Mankiller." The Mankiller was located north of the upper double wheel mill. A worker would watch the grinding/mixing process carefully, adding water when necessary to prevent the mix from drying out and exploding. The job was boring, and those assigned the task were given one-legged stools to sit on so that they would fall over and wake up if they dozed off. (EHS Collection.)

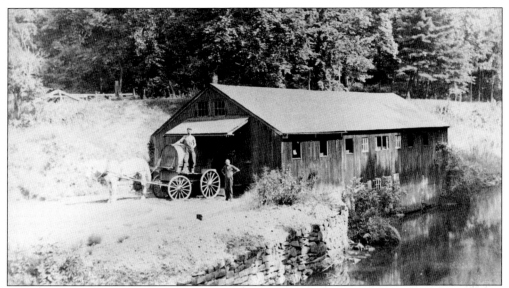

The glaze mill, another early mill, was located at the end of Gordon Lane. After the black powder was mixed, it was pressed into large cakes while still wet. Zinc rollers were then used in a process called "corning" to crack the cakes into coarse grains. The coarse powder was screened to separate the grains by size. The powder was then dried before "glazing," a process in which the dried powder was tumbled to polish the grains. After a final sifting to remove dust, the black powder was packaged for shipment in barrels, kegs, or canisters. (EHS Collection.)

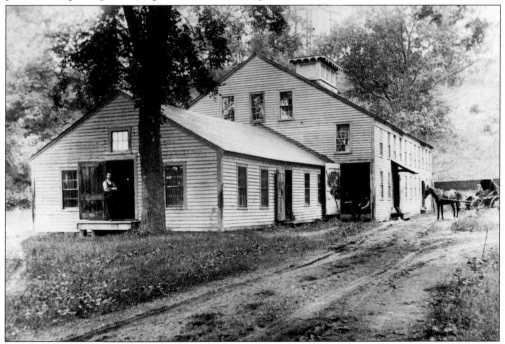

The packing house was also called the canister house. Black powder was packaged in wooden barrels, wooden kegs, and metal canisters of various sizes ranging from 1/4 pound to 25 pounds or more. The site of the packing house is now occupied by the baseball diamond in Powder Hollow. (EHS Collection.)

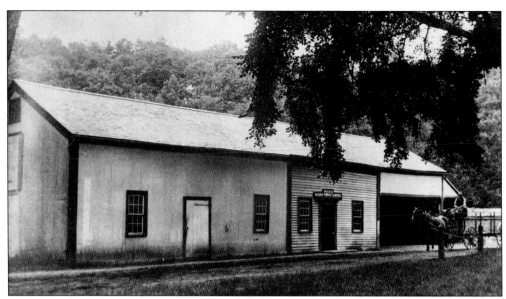

Many Hazard Powder Company buildings housed supporting operations, including the superintendent's office pictured in this view. Cooperages were needed to make wooden kegs and barrels, tinsmiths were needed to make canisters, and labels had to be printed, cut, and applied to the barrels, kegs, and canisters. Blacksmiths and machine shops were needed to make and repair tools and machinery and to shoe the many horses belonging to the mills. During the Civil War, only about 50 of the 125 or more Hazard Powder Company buildings were directly involved in manufacturing black powder. (EHS Collection.)

The building in the foreground is the water-powered machine shop that appears on an 1868 map of Powder Hollow. Rufus Stratton, later killed in the 1913 explosion, stands to the right of the entrance ramp. The Dust House, where the finished powder received its final sifting to remove dust, is seen on the right, behind the machine shop. It was built c. 1868 and still stands today. (EHS Collection.)

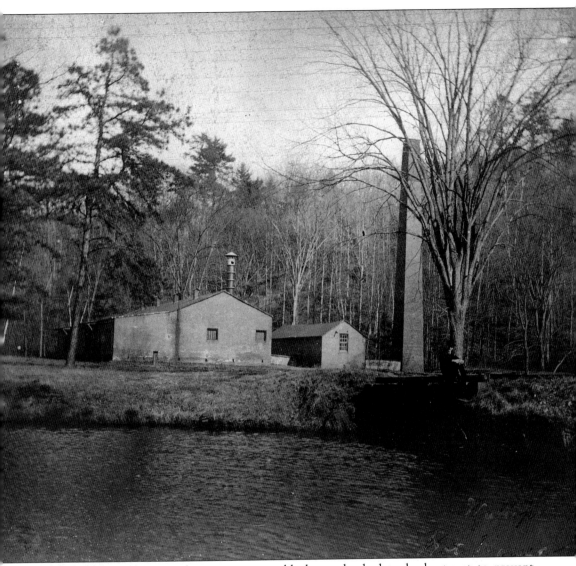

During most of the manufacturing process, black powder had to be kept wet to prevent explosions. It was necessary, however, to dry the powder before packaging it. The large building on the left, nicknamed the Wallop Hot House, was a drying house. For safety reasons the boiler that heated the drying house was located in the smaller boiler house building to the right of the drying house. To minimize the risk of stray cinders from the boiler touching off explosions in other mill buildings, the drying house, boiler house, and chimney were located some distance away from all of the other mill buildings. (EHS Collection.)

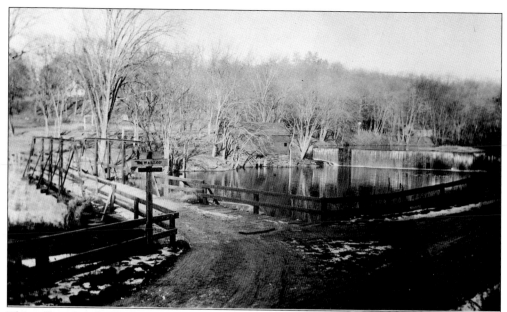

The mills in Powder Hollow depended upon water power for their operation. The Scantic River provided that power. Several dams and miles of canals were built to take advantage of the river. This view, looking northeast from Powder Hill Road, shows the stone Lower Dam that was washed out during the hurricane of 1938. The Upper Dam was a short distance up the river. The road on the right once led to Cooper Street, but it no longer exists. The South Maple Street bridge was replaced many years ago with a sturdier, iron bridge that is still in use today. (EHS Collection.)

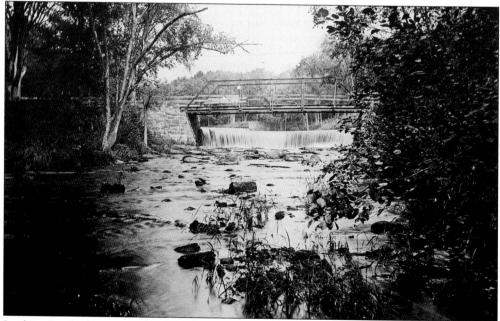

In this view looking east, the dam that is visible under the South Maple Street bridge is the wooden Horseshoe Dam. The right end of the stone Lower Dam is visible above the center of the Horseshoe Dam. (EHS Collection.)

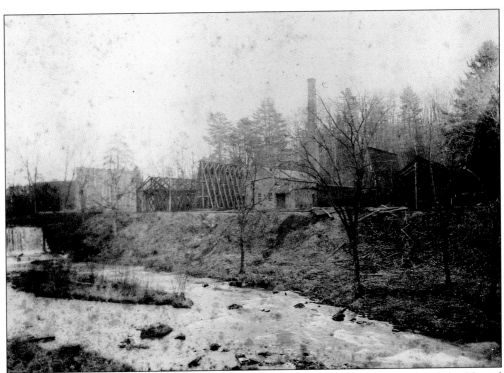

The end of the Civil War brought changes that ultimately led to the demise of the Hazard Powder Company. The U.S. Government dumped huge quantities of surplus black powder on the market, resulting in a tremendous drop in the price of gunpowder, which in turn drove many gunpowder companies to the edge of bankruptcy. Augustus Hazard died in the midst of this turmoil in 1868, without leaving an heir; his son Horace was killed in an explosion in 1855, and his other son Douglass died of consumption around the same time. A major explosion in 1871 destroyed several important mill buildings. Then came the economic panic of 1873.

In 1872, the three largest gunpowder manufacturers, the Hazard Powder Company, du Pont, and Laflin and Rand, formed the Gunpowder Trade Association of the United States, which "stabilized" the industry over the next two decades by either absorbing or bankrupting their competitors. In 1876, the major Hazard stockholders secretly sold out to du Pont.

The anti-monopoly Sherman Act was signed in 1890, but it was not until 1907 that the United States brought a suit against du Pont, which at that time was supplying at least 70 percent of the explosives used in the country. Four years later, du Pont was found guilty, and the business was divided into three smaller companies: E.I. du Pont de Nemours and Company, Atlas Powder, and Hercules Powder. Hercules Powder took control of the Hazard operation on December 15, 1912.

One month later, on January 14, 1913, the "New Works," which were located across the Scantic River from Cooper Street and were powered by water from the stone Upper Dam, were destroyed by a devastating explosion. The explosion killed three workers, Rufus Stratton, Charles Blunden, and Jacob Stocker, and, despite heavy blast walls between the mill buildings, did enough damage to bring an end to gunpowder manufacturing in Powder Hollow. (EHS Collection.)

The wheel mill at the "New Works" was destroyed in the explosion of January 14, 1913. The photograph shows many of the construction techniques necessary to protect the mills from explosions. The frame is made from heavy timbers and is strongly braced. The vertical pine-board sheathing was loosely attached to the frame to allow it to blow out and away from the building, yet remain fairly intact so that it could be quickly reassembled. Despite the many precautions taken to prevent explosions, close to 70 workers were killed in powder hollow during the eight decades of gunpowder production there. (EHS Collection.)

Six

THE SHAKER COMMUNITY
MOTHER ANN'S CONNECTICUT FOLLOWERS

On May 19, 1774, a small group of religious refugees boarded a ship in England that was bound for New York. The religious services held by the "United Society of Believers," as they later called themselves, began with silent meditation until a vision was received from God. The group would then start to shake, sing, and shout in response to the vision. Outsiders began to call them the shaking Quakers and eventually just "Shakers," a name which the Society adopted and used when advertising their produce and merchandise for sale. The Shakers believed that one of their group, Ann Lee, was the second coming of Christ. Mother Ann Lee traveled throughout New England, visiting Enfield three times, seeking converts to her religion. She was driven from town on her first visit by townspeople who feared her beliefs. Her second visit in 1782 also met with resistance, this time from an angry mob that had pursued her from Somers. Arrests were made and the County Court of Hartford fined the rioters. Ann Lee's final visit to Enfield in 1783 was peaceful. Five years later, a large Shaker Community was founded in northeastern Enfield.

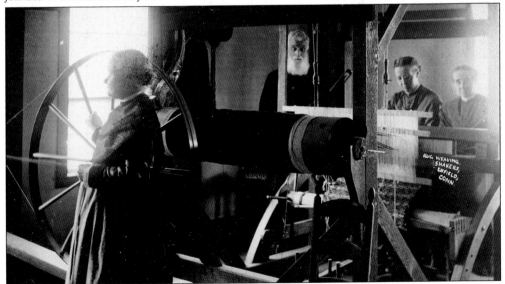

At the time this postcard depicting Enfield Shakers weaving a rug was published, the carpet mills in Thompsonville were turning out millions of yards of carpet each year. Times had changed, and the Enfield Shakers' way of life, like their rug-weaving business, was no longer viable. Miriam Offord, one of the last eldresses in Enfield, stands at the spinning wheel in this photograph. She published many postcards depicting the Enfield Shaker Community. George Clark, one of the last elders in Enfield, can be seen in the background. (Member Collection.)

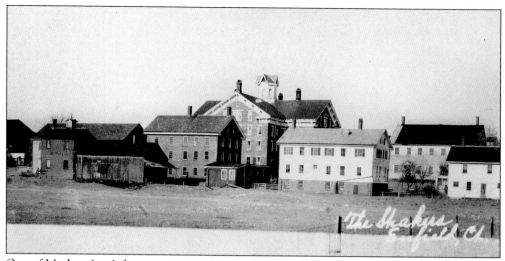

One of Mother Ann's first converts in America was Joseph Meacham, who was born in Enfield in 1741. He and Lucy Wright of Pittsfield, Massachusetts, became the first leaders of the United Society of Believers when it was established in New Lebanon, New York, in 1792. The Shakers practiced a celibate communal lifestyle, with the sexes segregated. Men and women were considered equals, however, and Meacham and Wright had equal standing and authority in the society. The first formal Shaker Community in Enfield was known as the Church Family. It was established on a large tract of land in northeastern Enfield that was donated by Joseph Meacham's brother David. (Member Collection.)

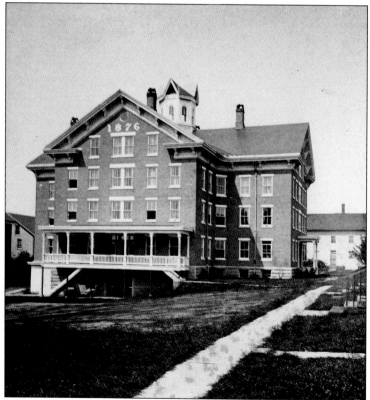

The Church Family dwelling house, built in 1876 at a cost of $65,000, was probably the most famous building built by the Enfield Shakers. Built of brick, it had steam heat, running water in the kitchen, and the most advanced kitchen appliances of the time. Part of the building was converted to a fully equipped hospital. (Member Collection.)

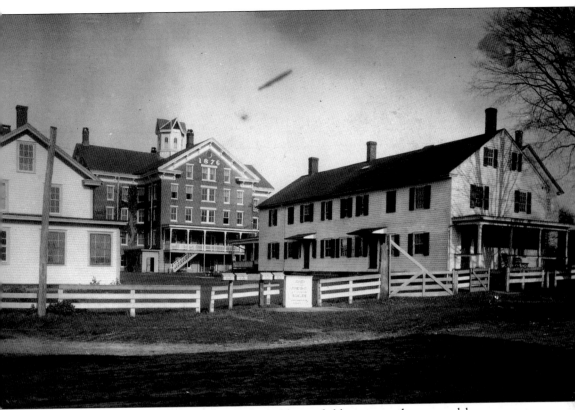

The leadership of each "family" consisted of two elders and eldresses, two deacons and deaconesses, and two trustees. The ministry of the Church Family selected the elders and eldresses for the other families in the community, who in turn, appointed the deacons, deaconesses, and trustees for their respective families. Each family had as many as 40 members during the Enfield Shakers' heyday in the mid-1850s.

The rules by which the Shakers lived were set down by the ministry. Guided by those rules, the elders and eldresses were responsible for maintaining the spiritual and physical health of their family. The deacons and deaconesses were responsible for the day-to-day operation of the community, supervising the work done by the brothers and sisters. The trustees were responsible for all business transactions with the outside world, ranging from sales of Shaker products to purchases of supplies, land, or even stocks and bonds.

Pictured is the Church Family's trustee's office, which faced Shaker Road. The building on the left was Elder George's shop. The 1876 dwelling house can be seen in the background, and the roofline of the Church Family's meetinghouse is visible above the right side of the trustee's office. (Member Collection.)

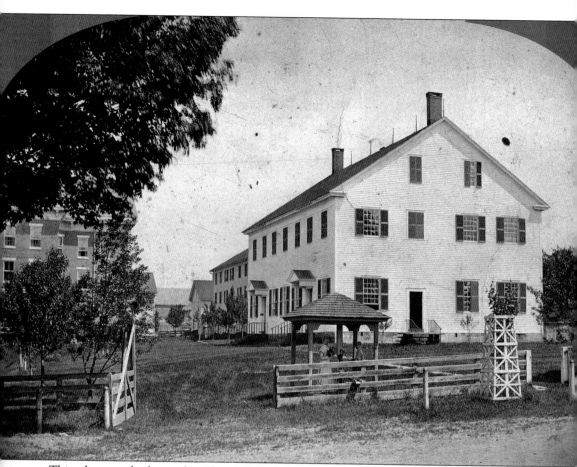

This photograph shows the Church Family meetinghouse prior to the construction of the trustee's office. The 1876 dwelling house is visible behind the trees on the left, and Shaker Road is in the foreground. Shaker meetinghouses had two doors, one for the men and one for the women. Careful examination reveals two Shaker sisters at the well pump, under the shelter by the gate. This building still stands today on the grounds of Carl Robinson Prison. (Member Collection.)

Shaker Station was located on the Springfield branch of the New York, New Haven, & Hartford Railroad where it crossed Shaker Road, west of the Church Family community. The station also served as a post office until 1911, and the Shaker Station, Connecticut postmark can be found on many postcards from the early 1900s. Careful examination will reveal a small dog in the chair between the man and the woman on the left porch. Many visitors to the Enfield Shaker Community arrived at Shaker Station. Some were from other Shaker communities, but many came to enjoy the delicious meals served to the public by the Shakers. (Member Collection.)

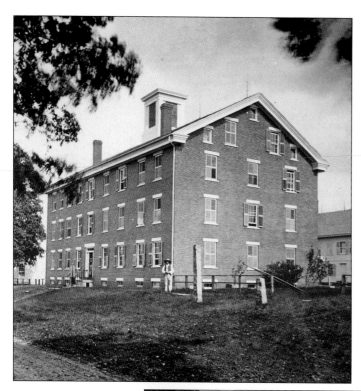

The South Family became the third Enfield Shaker Family when it was founded by Elders James Slate and Enoch Pease and Eldresses Judith Emerson and Clarisa Eley from the Church Family. In 1818, Elders Nathaniel Deming and Daniel Goodrich and Eldresses Dana Goodrich and Sarah Markham left the South Family to establish the West Family in the area of Bacon Road. In 1854, the West Family was brought back under the leadership of the South Family. One year earlier, in 1853, the South Family built a new dwelling house. It still stands today on Cybulski Road. (Member Collection.)

Several Shakers posed for this photograph, which is a view looking north past the South Family dwelling house and across Shaker farmland toward the Church Family community. The South Family was known for its excellent farm and modern farming practices. About 1897, Elder Thomas Stroud dehorned his Jersey cows and began a practice that is still followed today. He was also known for his greenhouses and poultry-raising practices. (Member Collection.)

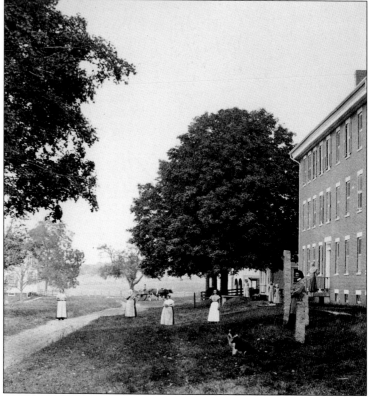

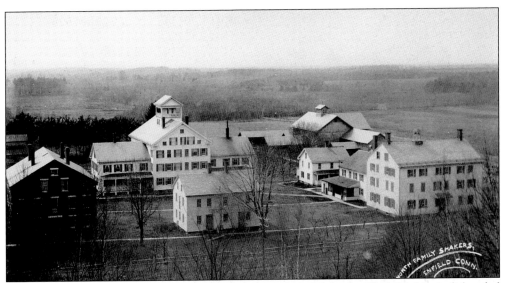

The North Family was the second Shaker community established in Enfield. It was disbanded in 1913, only one year before the last six Shakers in Enfield sold the remaining Shaker property to John B. Stewart of Windsor and Dr. John Philips of Wendham, Massachusetts, on November 24, 1914. The Shakers retained the right to use the buildings until April 1, 1915, after which the new owners were to provide them with quarters near the cemetery. The Shakers instead left to join other Shaker communities, with the last three leaving Enfield in 1917. (Member Collection.)

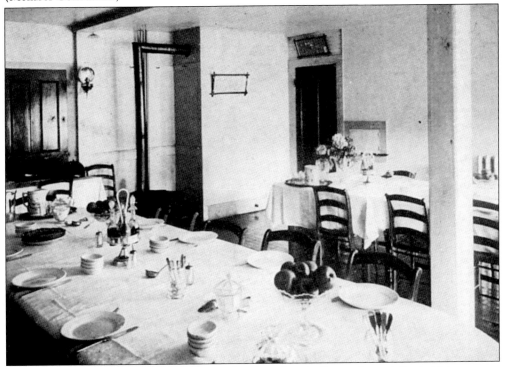

The North Family Shakers were known for their hospitality and good food. Visitors were welcome to dine at their settlement. (Member Collection.)

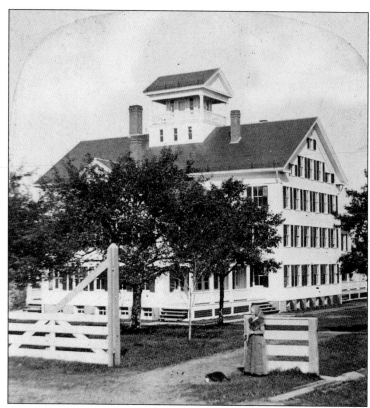

Like the Church Family's 1876 dwelling house, the North Family's dwelling house was the most recognizable building built by the family. This building is also known as the Sisters' House or Sisters' Dwelling. In another example of North Family hospitality, the sister standing by the gate is treating a cat to some milk. (Member Collection.)

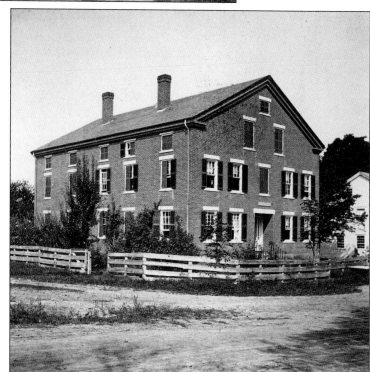

Each family had an office from which it conducted business with the outside world. The North Family was no exception. (Member Collection.)

Several members of the Copley family, including Sophia, Elizabeth, and Averill, joined the Enfield Shakers. Pictured is S. Emily Copley, who welcomed visitors to the North Family in the 1890s. (Member Collection.)

Born in 1841, John W. Copley joined the Enfield Shakers in 1852, at the age of 11 and left the community in 1865 at the age of 24. Changing economic and societal conditions resulted in the loss of many male members within all Shaker communities following the Civil War. During the early years of the movement, the communal lifestyle of the Shakers provided a safe life for many people. By the end of the Civil War, factory jobs and city tenements provided much of the same security without the strict religious practices. (Member Collection.)

By the 1900s the Shaker Community in Enfield had dwindled to just a few brothers and sisters. Elder George Clark shared leadership of the North Family with Eldress Miriam Offord during the last few years, before the North Family was disbanded in 1913. (Member Collection.)

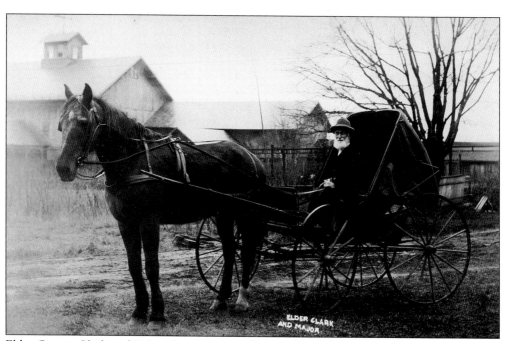

ELDER CLARK
AND MAJOR

Elder George Clark and "Major" are seen standing in front of the North Family barns in this early 1900s postcard. (Member Collection.)

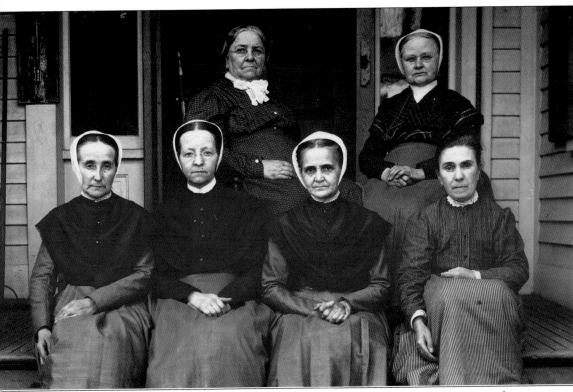

In this postcard view, Eldress Miriam Offord, who published many Enfield Shaker postcards, is seated on the right, in the back row.

After the Civil War the Shaker population at all communities became increasingly female as the younger brothers left to take advantage of the many new opportunities in the outside world. Photos of the Enfield Shakers from the early 1900s show, with few exceptions, sisters or female children in the care of the Shakers.

The average age of the Shakers also increased after the war, as fewer and fewer new converts of either gender joined the society. The last six Shakers in Enfield were Elder and Trustee Walter Shepherd, Eldress Caroline Tate, Matilda Schnell, Lucy Bowers, Maria Lyman, and Daniel Orcott. When the Shaker property was sold in 1914, Maria Lyman was about 80 years old, and Daniel Orcott was close to 85. (Member Collection.)

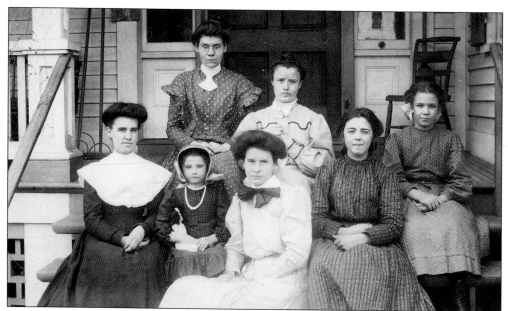

The Shakers had always practiced celibacy. They increased their numbers by converting adults to their faith. Orphans and other children whose parents could not care for them were taken into the community and cared for until they reached the age of 21, when they were given the choice of becoming Shakers or leaving the community. Pictured, from left to right, are as follows: (front row) Ethel Gullete, Hazel Robinson, Frances Bills, Rose Noga, and Jennie Noga; (back row) Adeline Patterson and unidentified. (Member Collection.)

Little Hazel Shaker, Hazel Robinson, may never have become a Shaker. Too many did not, and the Enfield Shaker Community faded away. (Member Collection.)